Simon Wilson

POP

Thames and Hudson · London

Roy Lichtenstein. *Knock, Knock,* 1961. Ink, $20\frac{1}{4} \times 19\frac{3}{4}$ (52.7 × 50.2)
Collection Mr and Mrs Michael Sonnabend, Paris.

© 1974 Thames and Hudson Ltd, London

Text filmset by Keyspools Ltd, Warrington, Lancs.
Litho origination by Paramount Litho Ltd, Wickford, Essex
Printed in Great Britain by Cox and Wyman Ltd,
London, Fakenham and Reading

ISBN 0 500 41053 4

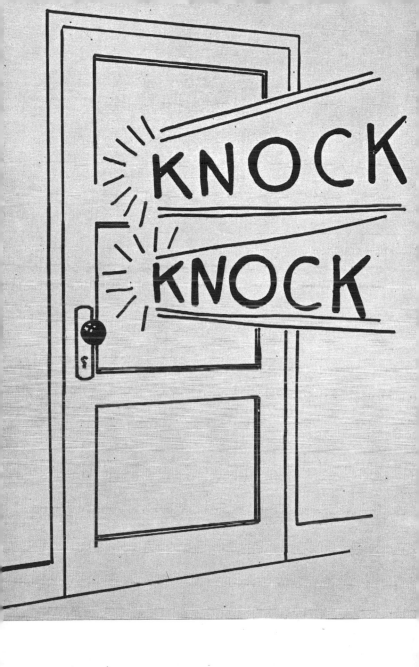

POP

The term 'Pop art' refers to a stylistic development in Western art which occurred roughly between 1956 and 1966 in Great Britain and the United States. There were related developments in Europe during the same period.

Pop art has three major distinguishing characteristics. Firstly, it is both figurative and realist, something that avant-garde art had not been since its very beginnings with Courbet's Realism. In 1861 Courbet published a manifesto of Realism in the Paris *Courrier du dimanche* in which he stated that for an artist the practice of art should involve 'bringing to bear his faculties on the ideas and objects of the period in which he lives'. Six years earlier he had stated the same thing in more personal terms in the short manifesto attached to the catalogue of his 1855 exhibition: 'To know in order to be able to do, that was my thought. To be in a position to translate the habits, the ideas, the appearance of my time . . . in a word, to make a living art, that is my aim.' This vitally important idea that artists must deal with the contemporary world and with life as well as with art is also the basis of Pop art. Just over a century after Courbet's manifesto, Roy Lichtenstein, one of the creators of Pop art in America, told an interviewer: 'Outside is the world; it's there. Pop art looks out into the world.'

Secondly, Pop was created in New York and London, and the world it looks out on is therefore the very special world of the great mid-twentieth-century metropolis. Pop is rooted in the urban environment. Not only that, but Pop looks at special aspects of that environment, aspects which because of their associations and cultural level seemed at first impossible as subjects for art. These were: comics and picture magazines; advertisements and packaging of all kinds; the world of popular entertainment, including Hollywood movies, pop music and fairgrounds, amusement ar-

cades, radio, television and tabloid newspapers; consumer durables, especially perhaps refrigerators and automobiles; highways and gas stations; foodstuffs, especially hot dogs, ice cream and pie; and, last but not least, money.

Thirdly, Pop artists deal with this subject matter in a very special way. On one hand they insist that the comic strip or soup can or whatever is simply a 'motif', an excuse for a painting, like an apple in a still-life by Cézanne. Roy Lichtenstein for example has stated: 'Once I am involved with the painting I think of it as an abstraction. Half the time they are upside down anyway when I work.' On the other hand, whereas in a Cézanne the motif is a traditional and familiar one, and it is easy for the spectator to ignore it and concentrate on the formal qualities of the painting, in Pop art the motif is in no way traditional, is of a kind which had never before been used as a basis for art, and therefore strongly engages the spectator's attention.

Not only was the motif of a new kind; its presentation was often (especially in the work of Roy Lichtenstein and Andy Warhol) startlingly literal – it looked more like the real thing than ever before in the history of art. The result was a kind of art which combined the abstract and the figurative in a quite new way: it was realism, but done in the light and full knowledge of all that had happened in modern art since the time of Courbet.

New York

Marcel Duchamp arrived in New York from Paris in 1915. With him he brought, as a present for his friend, the collector Walter Arensberg, one of his own works, a part of Paris (some of its air, in fact) simply enclosed in a glass globe. Duchamp had begun to produce works of this type, called 'readymades', two years before in 1913. They were bits of reality – usually man-made objects, but sometimes, as with *Paris Air*,

taken from nature – presented as art, either modified ('assisted') or with no more intervention by the artist than an inscription or just a signature. The first 'assisted readymade' was the 1913 *Bicycle Wheel*, which Duchamp mounted on a stool, and it was in New York in 1917 that he produced his most notorious readymade, the *Fountain,* a men's urinal of the wall-mounted type which Duchamp simply signed R. Mutt (apparently the name of a sanitary engineer). These works were not intended as sensuous objects but as demonstrations of an idea. The assisted readymades illustrate the proposition that the work of an artist – any artist – consists essentially in the assembling of pre-existent materials, which may perfectly well be readymade ones. The readymades proper go even further in showing that the creating of art need not necessarily be a manual activity but can be purely a matter of making choices. They also showed that no aspect of the world could be considered to lie outside the artist's scope. These were the ideas that were taken up again in New York (where Duchamp was still living and working) by Robert Rauschenberg and Jasper Johns, and passed on by them to the Pop artists.

1 In 1955 Rauschenberg made his painting *Bed,* consisting of real bedclothes with paint slurped and dripped over them, the whole then mounted and hung on the wall. This was one of the first of his so-called combine paintings, in which the paint is used to integrate real objects into the work. These paintings often intruded parts of themselves into the spectator's space – i.e. they became part of the real world – and it was at the time he was making them that Rauschenberg also made his significant and much-quoted remark that he was operating 'in the gap between art and life'. As well as the combine paintings Rauschenberg made fully three-dimensional works,

2 one of which, *Coca-Cola Plan* of 1958, prominently incorporated three Coca-Cola bottles, objects which were later to become one of the major motifs of Pop art.

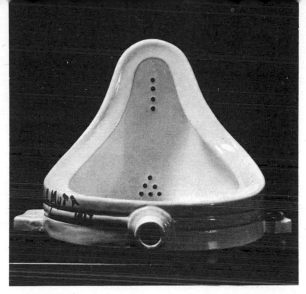

Marcel Duchamp. *Fountain,* 1917. Readymade, 14 × 19 × 24 (36 × 48 × 61). Original lost.

Like Rauschenberg, Jasper Johns is both a painter and a constructor of objects, and his contribution to the development of Pop art was, if anything, more significant than that of his fellow artist. Also from about 1955, Johns began to produce extraordinary paintings of familiar, even banal, objects and images, initially targets and the American flag, although later he used maps of the USA and numbers. These motifs possessed three vital qualities for Johns: they were very familiar; they were two-dimensional; and they were simple and visually striking. Depicting a two-dimensional object like the American flag in the two-dimensional medium of painting resulted in works which were at a casual glance indistinguishable from the real thing, an effect Johns strongly reinforced in some of his flag paintings by taking the flag right to the edge of the canvas and eliminating any illusion of it being an image on a ground. At the same time the flag

4

is a bold abstract design, and Johns's paintings of it are executed in a range of ravishing colours (sometimes close to the original, sometimes not), in a technique of extreme painterly refinement and sensuousness, so that they mark the first appearance in American painting of that combination of strong formal and abstract qualities with familiar, immediately recognizable imagery which is characteristic of Pop art.

3 Johns applied the same system in three-dimensional art when he made his famous sculpture of two Ballantyne Ale cans in 1960. More perhaps than the flag paintings, these beer cans look so close to their source as almost to preclude the possibility of their being art. But in fact they are beautifully cast in patinated bronze; the labels are meticulously hand-painted; and, thus translated, the twin cylinders assert a strongly sculptural quality.

The new possibilities offered by the art of Johns and Rauschenberg were taken up by the Pop artists in New York partly in reaction against the dominance of Abstract Expressionism. This kind of painting was based on the idea that art should be a direct record of the artist's inner impulses and states of mind, and it was therefore intensely personal and unworldly – precisely the opposite of Pop art, in fact. It manifested itself in a variety of forms, between the two extremes of Jackson Pollock's dynamic, gestural action painting and Mark Rothko's static, softly brushed fields of colour. It was Roy Lichtenstein who best articulated the Pop artists' attitude to Abstract Expressionism when he said: 'art has become extremely romantic and unrealistic, feeding on art, it is utopian, it has less and less to do with the world, it looks inward'. And again, commenting on the situation in the late 1950s when Abstract Expressionism had become hugely successful and was being rapidly debased as a style by second-rate artists: 'It was hard to get a painting that was despicable enough so that no one would hang it – everybody was hanging everything. It was almost

acceptable to hang a dripping paint rag, everybody was accustomed to this. The one thing everybody hated was commercial art; apparently they didn't hate that enough either.'

The problem then was twofold: art had become inward-looking and unrealistic, and it had become debased through commercial exploitation. The Pop artists' solution was to bring art firmly back into contact with the world and with life, and to look for subject matter that would ensure a degree of unacceptability. It is one of the ironies of art history that, as Lichtenstein wryly points out in his final remark quoted above, Pop art in New York became at least as commercial as Abstract Expressionism, if not more so, and in less than half the time.

Roy Lichtenstein began his career as a painter about 1951 with pictures which were, in his own words, 'mostly reinterpretations of those artists concerned with the opening of the West, such as Remington, with a subject matter of cowboys, Indians, treaty signings'. From 1957 his work became Abstract Expressionist in the prevailing mode, but about 1960, he says, 'I began putting hidden comic images into those paintings, such as Mickey Mouse, Donald Duck and Bugs Bunny. At the same time I was drawing little Mickey Mouses and things for my children and working from bubble gum wrappers. I remember specifically. Then it occurred to me to do one of these bubble gum wrappers, as is, large just to see what it would look like.' The result, he found, was extremely interesting, and thus began his use of advertising and comic strip imagery which in the next few years was to make him one of the most prominent New York Pop artists. Asked why he chose to use such apparently degraded, unaesthetic source material, Lichtenstein spoke perhaps for all the Pop artists when he replied: 'I accept it as being there, in the world. . . .

9

Signs and comic strips are interesting as subject-matter. There are certain things that are useable, forceful and vital about commercial art.'

Lichtenstein's early works drawn from advertising, *Roto Broil* (1961), *Chop* (1962), *Woman in Bath* (1963), reveal his striking ability to organize the crude but vital designs of his original sources into unified, powerful and coherent formal structures, while still retaining references to the original so strong that the spectator is constantly kept aware both of the figurative image, with its source (advertisements or comics), and of the traditional physical facts of painting – colour, line, form, composition and so on.

However, the formal, abstract message of Lichtenstein's painting was far from clear to everyone in the early days; many critics complained that he was simply blowing up comic strips and advertisements, that he did not 'transform' his sources. It is important to realize that Lichtenstein does alter his sources, although he still insists that he does not transform them. In 1963, replying to his critics, he said: 'Transformation is a strange word to use. It implies that art transforms. It doesn't, it just plain forms. Artists have never worked with the model – just with the painting. . . . My work is actually different from comic strips in that every mark is really in a different place, however slight the difference seems to some.'

Lichtenstein's working procedure is in fact, as follows: having located a source image he then makes a drawing or sketch of it (just as, for example, John Constable would make a sketch of a particular piece of Suffolk landscape for later elaboration into a full-size painting). The purpose of the sketch is to recompose rather than reproduce the original, and although Lichtenstein says he tries to make as little change as possible he sometimes combines two or three sources into one image or even makes it up altogether. He then projects the drawing on to the canvas using an epidiascope and traces it in pencil. Further compositional

5, 6

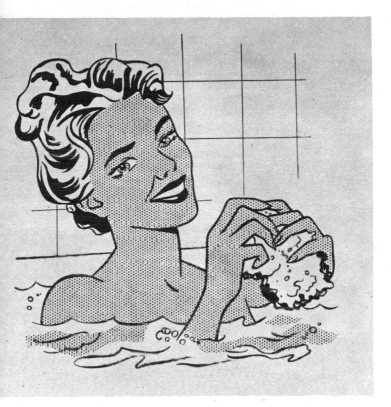

Roy Lichtenstein. *Woman in Bath,* 1963. Pencil and touche, $22\frac{1}{2} \times 22\frac{1}{2}$ (57.2 × 57.2). Collection John W. Weber, New York.

adjustments may be made at this stage, before the dots are stencilled on, the colours applied and the characteristic thick black or blue lines put in. The dots in particular help to reproduce the feel of the printing process used for comic strips and advertisements, but Lichtenstein retains too the bright primaries and impersonal surfaces of his sources, and he once said that he wanted his paintings to look programmed and that he wanted to hide the record of his hand.

6 The results of this procedure can be seen in *Roto Broil*, where the appliance itself, placed symmetrically against a uniform field of red, is treated in terms of bold simplified masses of black and white. Particularly striking is the rendering of the drainage holes in the frying-pan as black discs which take on a life of their own in the same way as they would in a completely abstract painting such as, for example, Vasarely's *Supernovae*. The symmetry of the composition is calculatedly broken by the black lines (paradoxically indicating highlights) on the right side of the appliance and by the protruding handle of the pan on the same side. And in *Woman in Bath* the prominent square grid contrasts strongly with the amazing system of flowing, swelling, organic linear forms which represents the girl's hair. This ability to create forms and compositions which are powerfully expressive in themselves yet remain readable as vivid representational images lies at the very core of Lichtenstein's genius and is the source of the extraordinary richness and complexity of his paintings.

Between 1963 and 1965 Lichtenstein produced two large groups of paintings which stand out from the rest of his work. In them forms, lines, colours, are increasingly abstract and expressive in themselves, and at the same time subject matter comes into greater prominence: based on romance and war comics respectively, these two groups of works deal with some of the fundamental dramas of human life. *M – Maybe* of 1965 depicts a girl (very attractive as in all Lichtenstein's love-comic paintings) waiting for a man (a theme taken up in a number of these works) in an imprecise but emphatically urban setting. Both her expression and the caption, 'M – Maybe he became ill and couldn't leave the studio', make it clear that she has been waiting a long time and is worried. Beyond that, like a Victorian narrative painter, Lichtenstein invites the spectator to speculate: who is the girl? who is the man with the studio? film star, photo-

grapher, broadcaster, artist even? and what is the nature of the situation? has he stood her up for another woman? is he really ill? fatally injured perhaps?

7, 8 *Sweet Dreams, Baby,* like the war images, is an icon of aggression, depicting as it does the single knockout blow that every man secretly wishes he could deliver in answer to an insult, to settle an argument, to win or protect a girl, and it refers to the American ideal of masculinity in more ways than one: the fist is a very clear phallic symbol, and although the recipient of the blow is a man the words of the caption, 'Sweet dreams, baby!' could equally well be addressed to a girl and take on an erotic implication. There is an interesting subgroup of the romance-comic paintings which consists of paintings exclusively of girls' heads. One of

9 these is the *Blonde Waiting* of 1964, one of the most beautifully and most strangely composed of all Lichtenstein's paintings, one of the masterpieces of Pop.

Andy Warhol was born in Pittsburgh, USA, probably in 1928. He went to Carnegie Institute of Technology in Pittsburgh from 1945 to 1949, then moved to New York where he has lived ever since. During the 1950s he worked as a commercial artist and was highly successful, winning the Art Directors' Club Medal for Shoe Advertisements in 1957. He had several one-man exhibitions of drawings and published a number of books of drawings on a variety of themes (cats and boys were two of them). His life style at this time was affluent and elegant, and he collected art, having, it appears, a particular taste for Surrealist paintings (he owned works by Magritte among others).

In 1960, at the same time as, but quite independently of, Roy Lichtenstein, he began to make paintings based on comic strips and advertisements. One of the earliest

10 of these is *Dick Tracy* of 1960, which still shows strong Abstract Expressionist influence: the caption is partially obscured by loosely brushed paint, drips of paint run down over Tracy's face, and that of his companion is treated partly as hard, comic-strip outline

and partly again as loosely brushed paint. Thus, as in a work of Rauschenberg of the mid 1950s, popular imagery is still being integrated into a painterly structure, although Warhol is already presenting that imagery in a much more dispassionate manner than ever Rauschenberg did. Unlike Lichtenstein, Warhol almost immediately abandoned comic-strip imagery, probably as being too anecdotal, and began to base his work on commercial and popular images that were much less obviously chosen by the artist with an eye to their content or visual quality. Indeed one of the crucial qualities of Warhol's images is their extreme obviousness: the most famous brands, Campbell's Soup, Coca-Cola; the most famous people, Elvis, Marilyn Monroe, Elizabeth Taylor; the most famous painting of the past, the Mona Lisa; the most familiar objects, dollar bills, newspapers. And when the individual image chosen is in itself an unfamiliar one, as with the car crashes, electric chairs, race riots, H-bomb explosions and so on, it always belongs to a category of images very familiar through the mass media. The effect of this choice of imagery is to give the baffling impression, even more strongly than in the case of Lichtenstein, that the artist has no interest in his images, that he is making no comment, that the images have no particular significance. Furthermore, Warhol presented them in such a way that they appeared to have undergone little or no processing by the artist – they had not been 'transformed' into art, although his early paintings were in fact meticulously hand-done.

In 1962 he began to make his paintings by the silk-screen printing process, a sophisticated form of stencil usually used by artists for the multiple production of graphic work. Not only did he take this unprecedented step of using a printing process for the production of paintings but he adopted a recent commercial development of silkscreen printing whereby the image, instead of being laboriously cut by hand, is applied to the screen by photo-mechanical means. The actual

14

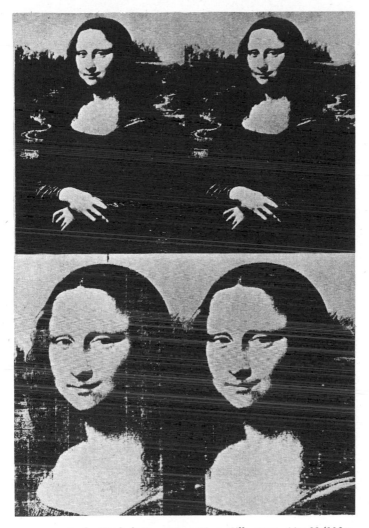

Andy Warhol. *Four Mona Lisas*. Silkscreen, 44 × 29 (112 × 74). The Metropolitan Museum of Art, New York. Gift of Henry Geldzahler.

printing Warhol did continue to do by hand, although it would often be carried out by an assistant under his supervision. In adopting this mechanical method Warhol seems to have simply been pursuing the logic of an art based on mass-produced imagery. But its effect, combined with the banality of his images, was to make his paintings appear completely meaningless, and this was reinforced by his frequent practice of repeating his images, often a large number of times, either on the same canvas or on separate canvases in series.

Of course, the paintings are not really meaningless. Warhol's images, in spite of their familiarity, in spite of their ready availability elsewhere than in his paintings, in spite, or even because, of their dispassionate presentation, remain extremely potent. His work, looked at overall, reveals certain constant and significant preoccupations with fame, with glamour, with death, with violence and disaster and with money. Nor do the images lack formal or aesthetic significance. Repetition is the means that Warhol uses to reduce them to the status of elements in the composition – Cézanne's apples again. The spectator's attention is directed away from the image as such and towards a consideration of what the artist has done to it. A close scrutiny of say *200 Campbell's Soup* or *Marilyn Diptych*, both early silkscreen paintings, reveals that no single image is quite the same as any other. There are for example variations in paint texture and density which affect the detail, and the colours are sometimes out of register, producing distortions of form. Even *Cow Wallpaper* is more comic statement than mechanical repetition.

13

As John Copland has pointed out, 'Though the silkscreen process is simple many things can go wrong. For instance, if the medium is stroked across the image unevenly, if the density of the medium varies, if the squeegee is worn or dirty, or if there is insufficient medium to complete a stroke, the image will not

print evenly. Parts of the image will become occluded or the dirt will print tracks, etc. The sharpness of the image will also vary according to the pressure exerted on the squeegee, or the angle it is held at. Many of these defficiencies will often work their way into the mesh and, unless the screen is cleaned, will show up in subsequent images. These normally accidental effects are often deliberately sought by Warhol.' So in Warhol's hands the silkscreen becomes a highly flexible means of creating expressive paint surfaces and forms. He exercises far more control over the production of his work than is generally supposed. As Richard Morphet tells us; 'Those who physically helped to make paintings in The Factory [Warhol's name for his studio] have explained how in even the most casual-seeming serial paintings Warhol was minutely concerned about the degree of painterly texture in background colours, and the exact choice of colour itself, not always taking it straight from the can but often mixing it into new hues and testing on strips of canvas until the desired shade was obtained'. Furthermore, Warhol frequently heightens his screened images with touches of colour applied with a brush (he has done this in some of the *Marilyn* paintings for example); and of course both the arrangement of the images (in regular rows, or occasionally in slightly more complex configurations, as in *Mona Lisa 1963,* where some of the images are on their side) and the determining of the relationship of the image or block of images to the ground are conscious compositional procedures.

There is no doubt that the most striking formal aspect of Warhol's painting is his vivid, varied and highly expressive use of colour, ranging from the close correspondence to the original in *200 Campbell's Soup* through the sinister monochrome washes of *Orange Disaster* and *Green Disaster*, and the sumptuous and subtle harmony of orange, blue and yellow of *Marilyn Diptych*, to the stunning variations (to which no reproduction can remotely do justice) of the *Marilyn*

11

prints of 1967. Finally, the almost complete dissolution of the image by intense and vibrant colour takes place in the great *Self-Portraits* of 1967.

14

In these, among his last works before he abandoned painting for film making and other activities, the wheel has turned full circle: since his first portraits of Marilyn in 1962 Warhol himself has become a star, a celebrity, has become in fact a subject for his own art. But these self-portraits must be among the most self-effacing in the history of art: the image is difficult to read, and deciphering it brings the realization that Warhol has based the painting on a photograph taken with his hand in front of his face half hiding it. Once again, and more forcibly than in any of his previous work, he is directing our attention away from the image, to the painting as something to look at in terms of coloured surfaces as you would look at a Monet or a Matisse. As he himself said, 'I think painting is the same as it has always been. It confuses me that people expect Pop art to make a comment or say that its adherents merely accept their environment. I've viewed most of the paintings I've loved – Mondrian's, Matisse's, Pollock's – as being rather deadpan in that sense. All painting is fact and that is enough; the paintings are charged with their very presence. The situation, physical ideas, physical presence – I feel this is the comment'; and: 'If you want to know about Andy Warhol just look at the surface of my paintings and films and me and there I am. There's nothing behind it.'

Claes Oldenburg was born in Sweden in 1929 and brought to the United States, where his father was on diplomatic service in New York, as a small child. In 1936 the family moved to Chicago, where Claes grew up and after taking a degree in Art and Literature at Yale University became an apprentice newspaper reporter. In 1952 he decided to become an artist and for two years attended the Art Institute of Chicago. In 1956 he moved to New York and settled on the

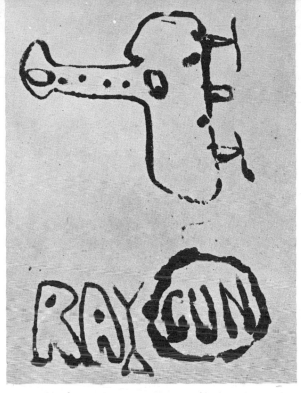

Claes Oldenburg. *Ray Gun Poster – Airplane Face*, 1960. Monoprint on newsprint, $17\frac{3}{4} \times 11\frac{7}{8}$ (45 × 30). Collection the Artist, New York.

Lower East Side, an area he has continued to live in, and which has exerted an important influence on him. From the beginning he had an exceptionally strong sense of engagement with the urban environment, 'the experience of the city', but in a significantly different aspect of it from those which had drawn the attention of Lichtenstein and Warhol: 'The streets, in particular, fascinated me. They seemed to have an existence of their own where I discovered a whole world of objects that I had never known before. Ordinary packages became sculptures in my eye, and I saw street refuse as elaborate accidental compositions.'

The results of this activity, his first mature works, were shown in two exhibitions at the Judson Gallery in 1959 and 1960. The second of these exhibitions was actually called 'The Street', and consisted of figures, signs and objects constructed from discarded or fragile materials: cardboard, paper, sacking, string. Many of the works were *Ray Guns* – strange objects made in a variety of materials but based on the ray gun of space comics, a kind of mascot and basic form for Oldenburg that engenders endless variations. It is a symbol of the city itself – Ray Gun spelt backwards is Nug Yar, which Oldenburg says sounds to him like New York – and as a phallic symbol also it relates to another of Oldenburg's fundamental preoccupations: the erotic. Taken as a whole, the exhibition was an extraordinary poetic evocation of the city through the medium of some of its humblest and least valued materials.

In the autumn of 1960, recalls Oldenburg, 'I drove around the city one day with Jimmy Dine. By chance we drove through Orchard Street, both sides of which are packed with small stores. As we drove I remember having a vision of 'The Store'. I saw, in my mind's eye a complete environment based on this theme. Again it seemed to me that I had discovered a new world, I began wandering through stores – all kinds and all over – as though they were museums. I saw the objects displayed in windows and on counters as precious works of art.'

In late summer 1961, Oldenburg moved to a studio in East Second Street which became 'The Store', filled with sculptures of food, clothing and other objects, made mainly of chicken-wire and plaster-soaked muslin or sacking, cheap and commonplace materials as before. In September 1962 he extended the idea of 'The Store' in a second version shown at the Green Gallery.

'The Store' sculptures were brightly, even vividly painted. Their colour is a very significant aspect of them; they are paintings as well as sculptures – and, as Oldenburg has stated, the paints themselves carry

a direct reference to their source in the urban store: 'The Street was a metaphor for line. The Store became a metaphor for colour. In an East Side paint store, I found a line of paints, Frisco Enamel, which came in seven particularly bright colours that seemed to symbolize the store to me. These colours became my palette. The paint would be used straight from the can without any mixing or blending of colour to paint reliefs of store objects.'

These works – *Giant Blue Pants, Breakfast Table, Kitchen Stove, White Shirt and Blue Tie* are a few of them – do not, as a work by Warhol or Lichtenstein does, refer you immediately to their source in the outside world. Some of them, it is true, incorporate real objects – the stove and the table for example – but these are primarily a means of display, like a sculpture pedestal in a museum. The effect of the reliefs of the store objects themselves is to stimulate the imagination. They are pants, shirt, food; but they could also be almost anything else, or simply abstract shapes, accumulations of plaster and paint. This effect has been well described (as reported by the critic Rublowsky) by a visitor to Oldenburg's studio who noticed an object he had made. 'It was a vaguely wedge-shaped piece of plaster crudely spattered with aluminium paint. He picked it up and tried to identify it. "It's a lady's handbag," he said, as he turned the object about in his hand. "No, it's an iron. No, it's a typewriter. No, it's a toaster. No, a piece of pie." Oldenburg was delighted: the object, which was nothing more than a shape the artist had been toying with, was exactly what the visitor had described. All the objects he named were embodied in that small wedge-shaped bit of plaster.'

This equivalence of form, the way in which one form can simultaneously relate to many other forms, fascinates Oldenburg and is the basis of his art.

In the second 'Store' exhibition Oldenburg showed a number of sculptures which differed from those in

the rest of the show, and from his earlier works, in two important ways. Some of them had been enormously 19 scaled up, like the *Hamburger, Popsicle, Price,* which is three feet high; and some of these were, a thing unprecedented in the history of sculpture, soft and yielding rather than hard and unchanging. One of the earliest of these soft sculptures was the *Floorburger (Giant Hamburger)* of 1962, which is no less than seven feet across and a little over four feet thick. It is made of canvas filled with foam and cardboard and painted.

Both these changes relate to Oldenburg's interest in the equivalence of forms. The change in scale of the hamburger opens up a whole new range of references, and, by removing the art object even further from its original source, draws the spectator's attention even more strongly than before to the purely sculptural qualities of the work: its shape, colour, texture and so on. This concern for scale culminated in the plans for giant monuments which Oldenburg drew up from 1965 onwards. These monuments are colossal versions 17 either of street furniture, like the *Giant Fireplug* which Oldenburg has imagined placed in the Civic Centre in 18 Chicago, or of everyday objects, like the *Trowel Scale B,* one of the regrettably few Oldenburg monuments to have been built and installed.

The change from hard to soft was even more farreaching; for a soft sculpture does not just passively refer to other forms but can actually metamorphose, change its shape. A soft sculpture by Oldenburg never looks the same in successive installations; and while it remains installed the action of gravity produces gradual changes: Oldenburg actually harnesses a fundamental natural force as part of the sculptural 20 process. The *Giant Soft Swedish Light Switch* of 1966, with its mysterious sagging forms, is a marvellous example of this.

Claes Oldenburg has tried to create an art which is universal in its significance. Taking his point of departure from the specific and familiar in everyday life,

he has attempted to make sculptures which stand for everything: sculptures that are embodiments of and metaphors for the whole of life. That this is his aim is made quite clear in his statement, one of the most moving manifestos in the history of modern art, first published in 1961:

'I am for an art that is political-erotical-mystical, that does something other than sit on its ass in a museum.

'I am for an art that grows up not knowing it is art at all, an art given the chance of having a starting point of zero.

'I am for an art that embroils itself with the everyday crap & still comes out on top.

'I am for an art that imitates the human, that is comic, if necessary, or violent or whatever is necessary.

'I am for an art that takes its forms from the lines of life itself, that twists and extends and accumulates and spits and drips and is heavy and coarse and blunt and sweet and stupid as life itself.'

James Rosenquist studied art at the University of Minnesota from 1952 to 1955. During one of his summer vacations he took a job with an industrial decorating company, travelling through the Midwest painting the outsides of warehouses and enormous grain storage bins. In 1955 he won a scholarship to the Art Students' League in New York where he completed his studies. In the following years he supported himself in a number of different jobs, but in particular he worked for some time painting billboards for an advertising company. Both the industrial decorating and the billboard painting clearly had a considerable effect on his development as an artist, affecting his subject matter, the overall scale of his work, and particularly his sense of scale *within* the painting, as well as his highly individual way of composing.

Recalling the first of his jobs, Rosenquist said: 'Now picture this scene: there's this stretch of wall

at least as big as a football field and way down in one corner is this man with a bucket of paint.' Speaking of the time he worked on the thirty- by one-hundred-foot billboard of the Astor-Victoria cinema in Times Square, he said that he had the opportunity 'to see things in a new relationship'. Working on a particular bit of figure or a letter of the alphabet, 'you couldn't see the whole thing at once, it was like infinity . . . everything looked different'. These statements have a direct reference to the pictorial devices used in Rosenquist's paintings like *I Love You with my Ford* (1961), one of his earlier masterpieces, in which enormous out-of-focus fragments of Ford motor car, girl's face, spaghetti in tomato, are brought together to express the erotic theme implied in the title: the Ford phallic symbol looms over the face of the girl, her eyes closed and lips parted in ecstasy, while below the consummation is somehow symbolized by the writhing, glutinous masses of spaghetti. Rosenquist's pictures reflect his own experience of billboard painting, but they also reflect the similarly fragmented kaleidoscopic visual experience of the city dweller as he walks through busy streets with buildings and hoardings towering over him or catches a brief glimpse of them from the windows of a car or bus.

21

Tom Wesselmann's university career was sporting rather than scholarly or artistic, and it was only when he was drafted into the army that he began to learn to draw, with the ambition of becoming a cartoonist. With this in mind, after leaving the army he enrolled at the Cincinnati Art Academy and then spent from 1957 to 1960 at the Cooper Union art school in New York. It was there that he discovered painting and the world of art, and towards the end of his final year he abandoned cartooning altogether and turned his whole attention to painting and collage. His early collages involved old newspapers, rags, leaves and old package labels used for the sake of their colour and texture, but a crucial development in his art took place

in 1960, when he began to use collage elements to represent themselves, and combined them with paint in works dealing in a new way with two traditional themes – the nude and the still-life. The subjects of his still-lifes are taken from billboard advertisements for food, drink, cigarettes and consumer durables (these last often represented by the real thing, so well integrated into the composition that it is difficult to tell whether it is painted or not).

Wesselmann's nudes, most of which belong to the series of *Great American Nudes* which he started in 1962 and is still continuing, derive their formal strength and qualities from Matisse, an important influence on Wesselmann; but they refer also to the soft-core porn glamour nude of the *Playboy* type of magazine. However, they are often both more frankly and more effectively erotic than any *Playboy* nude; and perhaps Wesselmann's greatest achievement has been to fill a long-standing gap in the history of art by fully eroticizing the nude in 'high-art' painting.

Robert Indiana uses words as images, and presents them in his paintings not only as forceful visual experiences but also as injunctions, slogans or messages to the spectator. These words relate to the American Dream and other aspects of American life which, however, Indiana does not accept without comment. 'It is pretty hard to swallow the whole thing about the American Dream. It started the day the Pilgrims landed, the dream, the idea that Americans have more to eat than anyone else. But I remember going to bed without enough to eat.' In his 1961 painting titled *The American Dream,* and in the later *Demuth Five,* the dream is seen in terms of a pinball game where winner takes all and a false move brings up the tilt sign. Using hard-edged imagery taken from the pinball machine, and flat areas of very bright colour, Indiana incorporates his message in a particularly abstract, impersonal and deadpan form, and he once said: 'I still use a brush because I have not found a

machine inexpensive enough to take its place.' Other paintings simply proclaim EAT, DIE, HUG, ERR, or, most famous of all, with its flat interlocking areas of shimmering complementary colours, LOVE.

Allan D'Arcangelo had his first exhibition in New York in 1963, by which time Pop art was thoroughly established. However, he at once made his own a particular area of imagery – the American highway – and has produced a whole series of paintings like *Highway No. 2* (1963), in which the immense distances of the United States are romantically evoked through the use of zooming perspective and the imagery of road signs. Like Robert Indiana, D'Arcangelo paints in an extremely tight, flat manner, his imagery always subsumed in a precise geometric composition.

The West Coast

American Pop art was created and developed in New York, but found rapid and early acceptance and a particular individual character on the West Coast, where activity was focused on the two centres of Los Angeles in the south and San Francisco in the north. Los Angeles emerged as the more important centre, and was the first to recognize the genius of Andy Warhol, giving him his first one-man show as a fully fledged Pop artist in 1962. The city of Los Angeles itself, perhaps the most extraordinary urban environment in the world, was an important influence on West Coast Pop, and it is also, of course, the home of Hollywood, itself an important influence on Pop art everywhere. Equally significant are the various exotic subcultures that flourish in the area: those of the surfers, the hot-rodders, the drag-racers, the car customizers and the outlaw motor cycle clubs like Satan's Slaves and, most famous of all, Hell's Angels.

Commemorated in the title of Tom Wolfe's essay *The Kandy Kolored Tangerine Flake Streamline Baby*, the amazing paint jobs and baroque bodywork created

by the car customizers and the elaborate decorations of the California surfboards are examples of an industrial folk art of great impact and brilliance which has set the tone for much West Coast Pop art. So too are the bizarre drag-racing cars and hot rods, and so is the Hell's Angels' 'chopped hog', a Harley-Davidson 74 which in the hands of the Angels is stripped down and rebuilt to become virtually a mobile piece of sculpture. The Angels' uniform is also a rich item of folk art, particularly the sleeveless denim jacket bearing the 'colours': a winged skull wearing a motor cycle helmet with the name Hell's Angels above with, below, the letters MC and the local chapter name, e.g. San Bernardino. These jackets may be further decorated with chains, swastikas and other signs, slogans and emblems: such as the number 13 (indicating use of marijuana), the notorious red wings, or the Angels' motto 'Born to lose'.

The world of customizing and of the big bikes is strongly reflected in the work of one of the two major Los Angeles Pop artists. Billy Al Bengston has worked since 1960 on a series of paintings of chevrons and motor-bike badges and parts treated as heraldic devices, the images placed centrally on the canvas and painted in glowing colours with immaculate precision and a high degree of finish. About 1962 his painting took on an even greater richness and gloss, when he began to use sprayed cellulose paint on hardboard and later actually on sheets of metal, thus getting even closer to the technique and medium of his sources. Some of these metal sheet works are artfully crumpled, thus adding a suggestion of accident and death to the glamorous perfection of the painted emblem.

The other major Los Angeles Pop artist is Ed Ruscha (pronounced, the artist insists, as Ruschay). He began using Pop imagery (packaging) in 1960 in paintings like *Box Smashed Flat*, where presentation of commercial imagery and what looks like Edwardian commercial lettering is still combined with a painterly

style. But his painting quickly took on an almost inhuman exquisiteness, precision and perfection of 27 finish, as in *Noise . . .* of 1963.

Like Indiana, Ruscha is fascinated by words, and these have always formed the principal subject matter of his paintings and graphics. In some works the words appear in isolation floating against backgrounds of beautifully graded colour that give a feeling of infinite coloured space. Sometimes associated images are introduced, such as the cocktail olive in *Sin,* and sometimes the word is given a specific context, as with the company names (e.g. 'Standard') for which the architecture becomes a setting in Ruscha's garage paintings 28 *(Standard Station, Amarillo, Texas).* One lithograph, where the word Hollywood streams unforgettably out of the sunset in the steep zooming perspective and giant lettering of wide-screen title sequences, exemplifies the manner in which Ruscha depicts his words in such a way that their meaning is conveyed pictorially as well as verbally.

Garages in themselves are one of Ruscha's most important motifs after words. They first appear in his work in 1962, not in painting or graphic work, but in a book: *Twenty-six Gasoline Stations,* consisting of 26 absolutely deadpan, factual, non-arty photographs of Western garages. The attitude behind these photographs comes very close to that of the New York Pop artists, and especially Warhol: the acceptance of aspects of the world which no one had considered in an art context before. *Twenty-six Gasoline Stations* was followed by *Various Small Fires* (1964), *Some Los Angeles Apartments* (1965), *On the Sunset Strip* (1966, a twenty-seven-foot fold-out continuous photograph of every building on the Strip), *Thirty-four Parking Lots* (1967) and others. As with Warhol's work, the nature of the motif eventually directs the spectator's attention to the manner of its presentation. Ruscha's books are beautiful visual objects, models of cool elegance and immaculate typography, finely printed

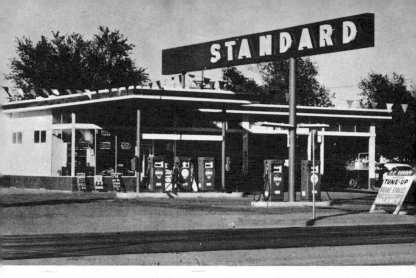

Ed Ruscha. *Standard, Amarillo, Texas,* 1962. Photograph from *Twenty-six Gasoline Stations.*

in limited editions at the artist's expense, although there is little of the connoisseur in his attitude towards them; asked once about the expense of production he replied: 'It's almost worth the money to have the thrill of seeing 400 exactly identical books stocked in front of you.' In the end it seems certain that these will be his most significant contribution to Pop art.

In North California, Pop art is similarly dominated by two major artists, who, like Bengston and Ruscha, have a certain amount in common both in their technique and in the way they handle their imagery.

Wayne Thiebaud employs thick, luscious and brilliantly hued paint to depict, as he says, 'Things which I feel have been overlooked. Maybe a lollypop tree has not seemed like a thing worth painting because of its banal references.' Thiebaud's subject matter consists mainly but not exclusively of cakes, sweets, pies, ice-creams and similar goodies which he presents in the usual deadpan, frontal or repetitive way of Pop art. But the way he actually paints these items is

unique to Thiebaud: he uses the paint not to depict them illusionistically but to recreate their textures and colours. Thiebaud has explained that his interest is in 'what happens when the relationship between paint and subject matter comes as close as I can get it – white, gooey, shiny, sticky oil paint spread out on top of a painted cake to 'become' frosting [icing]. It is playing with reality – making an illusion which grows out of an exploration of the propensities of materials.' *Refrigerator Pies* (1962) is typical of Thiebaud's work; and if in the end his paintings, like this one, have a highly synthetic as well as edible look about them it is because his source material itself is largely synthetic.

Mel Ramos uses similarly luscious paint but to rather different ends: he does not imitate textures like Thiebaud, nor does he interest himself in the same type of subject matter. After an early phase about 1962–63 of painting comic-book heroes and heroines, Ramos quickly found his own specific and personal iconography of nude pin-up girls. These young ladies are depicted by Ramos in often quite explicit sexual situations with either appropriately phallic forms of packaging, consumer goods or food like Coca-Cola bottles, cigarettes (in *Philip Morris*), a corn cob (in *Miss Corn Flakes*) or, particularly in his most recent works, with various animals, either symbolically phallic such as weasels and pelicans, traditionally highly-sexed like monkeys, or simply representative of brute maleness – gorillas for example. *Ode to Ang* plays a favourite Pop game with high art (the source is Ingres); and in depictions of girls with pumas and other big cats he has extended his range of erotic feeling by introducing an element of refined, almost decadent perversion. Ramos's art is probably intended as mild parody of the obvious Freudianism of Madison Avenue, but there is no doubt that it is also extremely enjoyable for what it is: light hearted, witty, glamorous, very high-quality pornography.

Great Britain

By the time artists in the U S A began to take up modern urban culture and its imagery as a source for their art, Pop art had already established itself in Great Britain and embarked on an entirely distinct and separate development which was influenced by American life, as seen through the mass media, but not by American art. In the late 1940s two artists emerged who were to have an important influence on the development of British Pop art. These two precursors were Francis Bacon and Eduardo Paolozzi.

From 1949 onwards Bacon began to use photographs, from mass-media sources among others, as a basis for his paintings. They were always considerably transformed, it is true, but Alloway, a critic who was around when these paintings first appeared, has written of the earliest of them, the series of screaming heads of 1949, that 'the photographic reference was conspicuous and much discussed at the time'. The source image for these (and many later works) was a still from the film *Battleship Potemkin* (1925), a close up of the face of the wounded nurse in the Odessa steps massacre sequence. He later moved on to using photographs by Eadweard Muybridge, made in the 1880s, of animals and humans in motion, and another major source has been *Positioning in Radiography*, a medical textbook on the making of X-ray photographs.

At the same time as he began to use photographs, Bacon also established the practice of basing paintings on works of art from the past. Here, one of his most important sources has been a reproduction of the famous portrait of Pope Innocent X by Velázquez in the Palazzo Doria in Rome, although significantly enough Bacon has never seen the original, and once, when he was in Rome, did not take the opportunity to do so.

Above all, Bacon combines in his paintings powerfully evocative images with equally forceful formal statements. Painting, he wrote in 1953, should be

concerned 'with attempting to make idea and tech-nique inseparable. Painting in this sense tends towards a complete interlocking of image and paint, so that the image is the paint and vice versa. Here the brush stroke creates the form and does not merely fill it in. Consequently every movement of the brush on the canvas alters the shape and implication of the image.' In spite of the clarity of his published views, many of his early critics discussed Bacon's work exclusively in terms of its imagery, ignoring its formal statement, just as they later did with the work of the Pop artists.

Finally, as the critic Lawrence Alloway has pointed out, 'Bacon was the only painter of an earlier generation who was regarded with respect by the younger artists in London. Moore, Nicholson, Pasmore, Sutherland . . . were considered to be irrelevant to any new art in the 1950s'. An important reason for this respect was the tough, uncompromising quality of his art and indeed its positive offensiveness to the then current standards of taste. Even as late as 1962 it was possible for one of London's leading critics to write of Bacon: 'Cruelty, ambiguous sex, a penchant for the perverse, all these occur in his art . . . he both gloats over the unusual and derives stimulus from the decadence he paints.' Any older artist capable of evoking this kind of response must have appealed greatly to the rebellious young.

While Francis Bacon stands as a father figure to British Pop art, Eduardo Paolozzi, born in Edinburgh of Italian immigrant parents in 1924, played a direct and crucial part in its development. From the earliest steps of his art education at Edinburgh College of Art, where he went in 1941, Paolozzi displayed a strong interest in popular culture and drew disapproval from his teachers for copying pictures of aeroplanes, footballers and film stars. At this time he also began making collages of material taken from magazines and other sources, including images from science fiction, aviation, technology, advertisements for food, domes-

Eduardo Paolozzi. *I Was a Rich Man's Plaything,* 1947.
Collage, 14 × 9¼ (35.5 × 24.8). Tate Gallery, London.

tic appliances and cars, comics, films, pin-ups, news-
papers and medical diagrams. Some of these collages
are direct and amazingly early harbingers of Pop art:
I Was a Rich Man's Plaything of 1947, for example, not
only has the word Pop in it but also contains a pin-up,
a part of a food advertisement, and, most remarkable
of all, a Coca-Cola bottle and the Coca-Cola sign simply

presented, in an emblematic way, as they so often were to be in Pop art more than a decade later.

The fact that Paolozzi's teachers disapproved of his interest in popular culture is highly significant. As John Russell says, 'Pop was a resistance movement: a classless commando which was directed against the Establishment in general and the art-Establishment in particular. It was against the old-style museum man, the old-style critic, the old-style dealer and the old-style collector.' and Richard Morphet has written that 'important roots of British Pop art lie in the anti-elitist attitudes of a generation whose daily life in their formative years steeped them exceptionally thoroughly in their eventual source material, the admass culture of modern life.'

British Pop art grew out of a whole generation's rejection of upper-class culture and out of a revolt within the art education system itself, against the provincialism and parochialism of English art colleges, where at that time Sickert and John were names to conjure with while Picasso and Matisse were considered dangerous foreigners.

Paolozzi was one of the first young artists to implement this revolt, and, as soon as he had finished at the Slade School in 1947 (he did not bother to sit the diploma examination), he removed himself to Paris where, at least, modern art was taken seriously.

In the early 1950s the Institute of Contemporary Arts in London was an informal meeting-place for artists, architects and writers, where they could drink and talk and the artists could show their work in the tiny gallery. In 1952 the management apparently began to feel that it had lost touch with the younger generation, and the result was the creation of what was in effect a sub-committee of the Institute which became known as the Independents' Group or IG. This group, first convened in the winter of 1952–53, then re-convened in winter 1954–55 after missing a year, was responsible for the formulation, discussion

and dissemination of most of the basic ideas not only of Pop art but of much other new British art in the late 1950s and early 1960s.

The first season's programme concentrated largely on technology, a novel concern for artists in Britain at that period and one that was to play an important role in British Pop art; but the very first meeting was dominated by a lecture entitled *Bunk,* given by Paolozzi, during which he projected a large number of his collages, as well as many pulp images presented directly, untampered with except for the act of isolation. These included covers from *Amazing Science Fiction,* advertisements for Cadillac and Chevrolet cars, a page of drawings from the Disney film *Mother Goose Goes to Hollywood,* and sheets of US Army aircraft insignia. This was the first time that pulp imagery had been talked about in public in a serious way, although even within the IG, it seemed, the idea that such imagery not only could be the source of art, but (as Paolozzi had implied) could be art itself, took some time to gain acceptance.

In 1953, however, the IG staged an exhibition with the significant title 'Parallel of Art and Life', which consisted of blown-up photographs, not only hung all over the walls of the ICA Gallery but suspended from the ceiling and even propped against the walls. The exhibition was arranged by Paolozzi and four others (Nigel Henderson, Peter and Alison Smithson and Ronald Jenkins), and, like Paolozzi's lecture (which he gave at a number of other places after the ICA, including the School of Architecture at Cambridge and the Arts Club, Oxford), it presented the organizers' world, a world in which life and art have equal importance through the association, without comment, of a large number of images. These included photographs of paintings by Picasso, Kandinsky, Klee and Dubuffet, microscope photographs, aerial photographs, photographs of car crashes, Pompeii victims, primitive settlements and technological processes.

When the IG was re-convened in 1954 by Lawrence Alloway and John McHale, the theme this time was, quite explicitly, popular culture, Alloway later wrote: 'This topic was arrived at as the result of a snowballing conversation in London which involved Paolozzi, the Smithsons, Henderson, Reyner Banham, Richard Hamilton, John McHale and myself. We discovered that we had in common a vernacular culture that persisted beyond any special interest or skills in art, architecture, design or art criticism that any of us might possess. The area of contact was mass-produced urban culture: movies, science fiction, advertising, Pop music. We felt none of the dislike of commercial culture standard among most intellectuals, but accepted it as a fact, discussed it in detail, and consumed it enthusiastically.'

Richard Hamilton was a member of the Independents' Group from the beginning, and in 1954–55 he began to play an increasingly important part in the development of Pop art both inside and outside the Group. In 1955 he had an exhibition of his work of the last four years at the Hanover Gallery. These paintings were much discussed by the IG, particularly the four *Trainsition* (sic) ones and *Carapace*, which, as Alloway pointed out, were concerned with a classic situation of the Hollywood movie of the time – the speeding car seen from a moving train, and (in *Carapace*) the view through the windscreen of a moving car. Also in 1955, Hamilton designed and organized an exhibition, 'man, machine and motion', which was shown in Newcastle upon Tyne as well as at the ICA in London, and which pursued, mainly through photographs, the idea of the aesthetic possibilities of the machine which had been discussed in the first sessions of the IG in 1952. Then, in 1956, the IG organized an exhibition called 'This is Tomorrow' at the Whitechapel Gallery in London. The exhibition was intended as an exploration of the possibilities of integrating the various visual arts; in it, twelve teams, each supposedly consisting

of a painter, a sculptor and an architect, worked to produce as many environments.

Hamilton, with John McHale and the architect John Voelcker, produced a section which included a profusion of images from popular magazines, comics and film publicity, including the sixteen-foot robot which had been used to advertise a science fiction film at the London Pavilion and a life-size still of Marilyn Monroe in *The Seven Year Itch*. A juke box played continuously.

For the exhibition poster, and for reproduction in the catalogue, Hamilton made a special collage. *Just What Is It That Makes Today's Homes So Different, So Appealing?*, a comprehensive anthology of Pop imagery and sources, with its comic hung on the wall as a painting, its can of ham displayed as sculpture, its pin-up imagery and emphasis on glamorous consumer goods, is uncannily prophetic of later developments in Pop art. Also it prominently features the word Pop as an abbreviation for 'popular culture' or 'popular art'. Artists at that time still did not use the word to refer to what they themselves did; when the Independent Group talked about Pop art they were still referring to mass commercial culture itself, and in January 1957 Hamilton produced a now famous list of its qualities:

Popular (designed for mass audience)
Transient (short term solution)
Expendable (easily forgotten)
Low Cost
Mass Produced
Young (aimed at Youth)
Witty
Sexy
Gimmicky
Glamorous
Big Business

This formulation Hamilton included in a letter to Alison and Peter Smithson, who had also been involved in 'This is Tomorrow', and in the same letter he proposed, as a follow-up to 'This is Tomorrow', another exhibition similarly created by teams, *in which the work exhibited would conform to his definition of Pop* – it would in other words be Pop art in the sense that the term later generally came to be understood: 'fine' or 'high' art based on commercial art sources.

From then on Hamilton attempted to fulfil the definition in his work both by actually giving it the qualities he had listed (although he would not make it expendable) and by treating those qualities as part of his subject matter. Since 1956 one of Hamilton's principal preoccupations has been with consumer goods and their role in society, particularly as revealed through the ways in which they are advertised. The motor car, of course, is *the* consumer good, and the first two paintings he made after 'This is Tomorrow', *Hommage à Chrysler Corp* (1957) and *Hers is a Lush Situation* (1958), both take their point of departure from advertisements for American cars, of the type that use glamorous women to sell the car. Both already reveal the elaborate and witty transformations Hamilton imposes on his source imagery, and his deep interest in the process of painting itself.

32 Later in 1958 Hamilton produced another consumer goods painting, *$he*, which perhaps more than any other of his early works encapsulates his formal, iconographic and sociological preoccupations. It is one of the first masterpieces of British Pop art. The theme of this painting, put at its simplest, is the use of sex by advertisers to sell consumer appliances, a theme wittily suggested by Hamilton in the title, where the first letter is written as a dollar sign. Or, as Hamilton himself put it, '*$he* is a sieved reflection of the ad man's paraphrase of the consumers' dream.' He also said that 'Woman in the Home' was a possible alternative title for the picture. These two statements

occur in a lengthy account, 'An Exposition of *$he*', by Hamilton, published in the magazine *Architectural Design* in October 1962. He begins by comparing the artist's image of woman in the 1950s with the ad man's image of her at the same period: 'Art's Woman in the fifties was anachronistic, as close to us as a smell in the drain; bloated, pink-crutched, pin-headed and lecherous; remote from the cool woman image outside fine art.' In the advertisement, 'she is truly sensual but she acts her sensuality and the performance is full of wit. Although the most precious of adornments, she is often treated as just a styling accessory. The worst thing that can happen to a girl, according to the ads, is that she should fail to be exquisitely at ease in her appliance setting – the setting that now does much to establish our attitude to a woman in the way that her clothes used to. Sex is everywhere, symbolized in the glamor of mass-produced luxury – the interplay of fleshy plastic and smooth, fleshier metal.' Hamilton rejected the fine-art image of woman in favour of the commercial-art one with its much greater relevance to the realities of contemporary life; and in *$he* he brilliantly introduced it into fine art, creating a new vision of art's most ancient motif.

The immediate visual sources for the painting were as follows. For the woman a photograph from *Esquire* magazine of a model known as Vikky (The Back) Dougan, who specialized in modelling backless dresses and swimsuits. In the *Esquire* photo she is seen from behind wearing a dress plunging so low as to reveal the beginning of the cleavage of her buttocks. Hamilton notes: 'The only pin-up I can remember having a greater impact in art circles was Brigitte Bardot spread piecemeal through *Reveille* in October 1957.' Then, for the appliances, firstly what Hamilton described as 'a brilliant high shot of the cornucopic refrigerator' – an advertisement for an R C A Whirlpool fridge/freezer which gave him the overall layout for the painting – and secondly, for the object in the fore-

ground, two advertisements, one for a Westinghouse vacuum cleaner and one for GEC small appliances.

. The source images are elaborately processed by Hamilton, and these processes are perhaps the key to an understanding of his art, for their effect is to produce a highly abstract painting in which the artist's most obvious concern is with the extension of the language of painting, in other words the exploration of the medium itself. This is dazzlingly illustrated in *$he* by the virtuoso range of treatment of the individual elements of the composition: the fridge door is a smooth fleshy pink (the colour of the original in the ad, which Hamilton called Cadillac pink and which he said 'was adopted with enthusiasm for the painting'), while within it is a Coca-Cola bottle treated in the traditional manner of European still-life painting, although perhaps its most recent ancestors are the bottles in Manet's *Bar at the Folies-Bergère*. The combined toaster and vacuum cleaner in the foreground (named the 'Toastuum' by Hamilton) is immaculately air-brushed (i.e. sprayed) in aluminium paint, while the linking passage from Toastuum to fridge door is entirely painterly, even to the extent of paint being allowed to run down the picture surface, no doubt a conscious reference to Abstract Expressionism. The woman's shoulder and breasts are, Hamilton's phrase, 'lovingly air-brushed', this time to the exact tone and texture the flesh of women takes on in glossy magazines; but her single eye is a piece of collage, a joke winking plastic eye, given to Hamilton by a friend from Germany after he had already been working on *$he* for two and a half years, and instantly incorporated by him into the painting. (The element of chance often plays a vital role in Hamilton's otherwise highly controlled art.) This eye is a characteristic piece of wit, as is the row of dots springing from the Toastuum, which indicate the flight path of the toast when it is automatically popped up. The woman's skirt is collage, and in relief as well, made of $\frac{1}{8}$-inch plywood

40

and given an extra sculptural quality by delicate modelling of the surface, which Hamilton says can best be explored by sensitive fingers rather than the eye. Also collage is the freeze compartment of the fridge, a photograph of a detail from an advertisement for an automatic defrosting system, blown up and stuck into the painting.

Finally, the mechanisms of Hamilton's apparently arbitrary selection of particular fragments from his sources, and his also apparently arbitrary manipulation of them once selected, can be best understood by reference to the figure of the woman in *$he*: for example, the shape of the area of her breasts and shoulders is partly the result of Hamilton's desire to combine Vikky Dougan's back ('too good to miss', he said) with breasts – essential to the ad man's image of woman (the breasts in fact are from another pin-up) and partly from his desire also to perpetrate a mild erotic joke by giving the breasts two alternative readings, one of which introduces a large, pointed, dark-aureoled nipple into the immaculate kitchen. Similarly, the scooped-out part of the relief represents the area of flesh revealed by the deep plunge line of Vikky Dougan's dress, but, says Hamilton, 'it also suggested an apron effect in negative: this was nice – an apron, however minute, is fundamental to the woman-in-the-house image'.

Hamilton has always been one of the least productive, in quantitative terms, of all major contemporary artists, but everything he does produce is elaborately considered, deeply pondered and densely packed with ideas. Every work is a major statement, the result of a complex conceptual process, and it is not surprising therefore that they have the look more of the products of the engineer's drawing-board than of those of the artist's easel. He was the direct inheritor of Duchamp's attitude towards the making of art.

At the time when Richard Hamilton was creating his technologically and ad-mass orientated art, Peter

Blake, an artist ten years younger, was developing a rather different kind of Pop art, remote from the cool intellectualism of Hamilton. Blake is interested neither in technology nor in consumer goods, as he explained in an interview in 1963: 'For me Pop art is often rooted in nostalgia: the nostalgia of old popular things. And though I'm also continually trying to establish a new Pop art, one which stems directly from our own time, I'm always looking back at the sources of the idiom and trying to find the technical forms that will best recapture the authentic feel of folk pop.' Blake's ultimate sources thus lie in Victoriana and Edwardiana, and his art is directly rooted in the world of his own childhood and youth (toy shops, comics, badges), in the world of pop music (Elvis Presley, Cliff Richard) and popular entertainers and film stars (Sammy Davis Jr), and in the world of fairgrounds where he has drawn on the traditional heraldic carnival style of lettering and decoration as well as on fairground personalities (tattooed ladies, etc.) and the bric-à-brac of fairground prizes. He also has a great affection for two popular entertainments particularly dear to the British, all-in wrestling and strip-tease. Like other major Pop artists, he also uses other art, both contemporary and of the past, as part of the subject matter of his own.

33 *On The Balcony,* which Blake painted between 1955 and 1957, is, like Hamilton's *$he,* one of the first substantial masterpieces of British Pop art. In it Blake has painted no less than twenty-seven variations on the theme *On The Balcony,* the most important of which is the row of four young people in the centre of the picture. Three of them are displaying an array of badges including 'I Love Elvis', 'I like the Hi-Los', and badges of children's clubs like A B C Minors and I-Spy. Two of them are wearing Union Jacks, indicating their allegiance to Queen and Country, and this kind of pop patriotism, very much in the air in the 1950s in the aftermath of the Festival of Britain and the

Coronation (people talked about a New Elizabethan Age), is a major theme of the painting, taken up again in no less than three representations of the Royal Family (the whole family on the balcony at Buckingham Palace, the *Life* magazine cover of Princess Margaret, and the Queen Mother with Winston Churchill). This emphatic Britishness remains an important part of Blake's art.

The fourth figure looks very like a self-portrait, and this reading seems to be confirmed by the fact that the figure displays no badges, only a portrait of John Minton, an artist who had considerable influence in British art schools in the 1950s, who taught Blake at the Royal College, of whom Blake once said: 'if he looked at your picture you felt it was worth while going on', and who committed suicide in 1957. The portrait of him in Blake's picture is inscribed 'In sincere memory', and was clearly added as a personal tribute. The fourth figure is also holding a painting, which would seem to identify him as an artist. These are the first of the many references to art in *On The Balcony*. The most obvious is the reproduction of Manet's famous painting *The Balcony* of 1869, but Blake has also included, very interestingly, his idea of what three contemporaries, two of whom have since become well-known abstract artists, might have done with the same subject. In the middle behind the royal family is a Robyn Denny, immediately below it is a Richard Smith, and lower down is a thickly impasted Leon Kossoff.

Commercial art sources are introduced in the various renderings of packaging, especially the still-life group on the table (the table acting as a 'balcony'), which prominently features a Kellogg's corn flake packet.

One of the most significant aspects of this painting is the way in which Blake plays on the difference between illusion and reality. The corn flake packet is a three-dimensional object rendered on the flat canvas

in a traditional illusionistic way, but the magazine covers for example, being flat themselves, look as if they might be collage (a method Blake has made extensive use of), while the Leon Kossoff is a real miniature abstract painting – you could almost cut it out and frame it.

34 In 1960 Blake had an important one-man exhibition at the ICA, where he showed a large group of recent works combining painting and collage. These works were done, not on canvas, but on solid pieces of board sometimes treated as a plain surface but frequently divided into compartments by beading or strips of wood and sometimes resembling doors or walls. In the compartments were images of pop stars, pin-ups or entertainers. In contrast to these collage elements and forming a setting for them, the boards were emblazoned with abstract designs, emblems and lettering painted in enamels in a manner strongly reminiscent of the traditional decoration of fairground booths. The exhibition included *Elvis and Cliff, Girlie Door, Kim Novak Wall, Sinatra Door* and *Everly Wall.*

In 1961 Blake made *Love Wall,* his largest work to date, a remarkable compilation of images of love ranging from contemporary pin-ups, romance comics, film stills and seaside postcards to Edwardian wedding photographs, valentines and birthday cards. The word LOVE (above an emblematic heart) is painted into one of the panels, forming a small individual painting which is remarkable for its strong, hard-edge forms and abstract use of colour.

Peter Blake's contribution to the first phase of British Pop art has often been underestimated; by 1961 he had produced a whole group of works, including those shown in his 1960 ICA show, which are the purest Pop art in that they combine vivid Pop imagery and direct collage elements with equally vivid abstract forms derived from the same Pop sources.

The second phase of British Pop art began in 1961, when David Hockney, Allen Jones, Derek Boshier,

Peter Phillips, Patrick Caulfield and others, all students at the Royal College of Art, made a great impact with the work they showed at the 'Young Contemporaries' exhibition. Besides inheriting the situation created by Bacon, Paolozzi, Hamilton and Blake, this young group were also influenced by two other artists of the same age as Blake, Richard Smith and the American R. B. Kitaj, although neither was strictly speaking a Pop artist.

Kitaj was a fellow-student of Hockney and the rest at the Royal College from 1957 to 1961. He was older, more experienced and more seriously involved in art than any of them, and his paintings were concerned with exploring problems of representation. Allen Jones spoke perhaps for all the Royal College group when in 1965 he recalled: 'I learned more, I think, about an attitude to painting merely from watching him. I didn't speak to him very much, but suddently I thought this was something vital in comparison to everything else at the College, in other words the influence wasn't one of imagery but of a dedicated professionalism and real toughness about painting.' There is no doubt that Kitaj's actual way of painting, in which significant figurative images are integrated by strongly painterly means (loose brushwork, etc.) into an often complex compositional structure, had a strong impact particularly on Hockney, Jones and Boshier.

Richard Smith was one of a small group of British painters (Robyn Denny and Bernard Cohen were others) who, in the late 1950s and early 1960s, were looking at Pop sources but using them as the basis for a completely abstract art. Smith left the Royal College in 1957, went to America, where he stayed until 1961, and there developed a painterly, large-scale art rooted in the mass-media but in which the source material was not presented (as it always is in true Pop art) as a strongly figurative image. Rather, certain of its qualities, of colour or of shape, were isolated as the

38

basis for the painting. In his series of cigarette-packet paintings of the early 1960s, for example, form and colour are derived from the packet itself, and the large scale and soft-focus treatment come from wide-screen cinema cigarette advertisements where a packet may appear six feet high and, when viewed from close to, dissolves into blurred and shifting washes of colour.

Smith has explained that he wanted to extend the expressive range of painting, to create a new kind of fine art experience through the use of commercial art: 'This would be possible, I thought, through paintings that shared scale, colour, texture, almost a shared *matière* with an aspect of the mass-media.' This attitude in itself must have been influential, but Smith's paintings also demonstrated to the younger Pop artists not only a new sense of scale, quite different from that of Hamilton and Blake, but also the possibility of a broad painterly treatment of Pop source material.

David Hockney, like Allen Jones, has recorded his appreciation of R. B. Kitaj, who, he says, has affected him more than anyone else 'not only as an artist but as a person'. Other influences on Hockney were Francis Bacon and the French artist Jean Dubuffet, who may well have drawn his attention to the aesthetic possibilities of the most important of his early stylistic sources, graffiti, an aspect of the urban scene not really looked at by any other Pop artist. Indeed, although the debt to Bacon, especially, is apparent in Hockney's work in the early 1960s, its primary visual quality comes from the extraordinary graffiti-like drawing of the figures and from the scrawled messages and individual words, parts of words and numbers which in some cases come to dominate the painting. (Hockney has explained that he wrote on many of his paintings at this time in order to make his meaning as clear as possible.) His paintings also have the usual Pop characteristic of combining strongly abstract elements with vivid figurative imagery. In, for

example, *The Cha Cha Cha that was Danced in the Early Hours of the 24th March* (1961), one of his best early paintings, the dancing figure and the words and messages are set against flat rectangles of emblematic red and blue at the top of the picture, a large expanse of raw untouched canvas in the middle and a flat strip of mauve at the lower edge.

The subject matter of Hockney's art is broadly autobiographical, and in the early 1960s, while still at the Royal College, his principal preoccupations, not surprisingly perhaps, were with art, and the making of art, and sex. These themes come strongly through in his painting, even when, as in another major early work, his shaped canvas painting of a Ty-Phoo tea packet, he is ostensibly concerned with that other major Pop subject, packaging and advertising imagery. In particular, the title of this work, *Tea Painting in an Illusionistic Style*, draws attention to the formal statement, while the artist's erotic interests are expressed in the life-size figure of a naked boy who appears (part of the whole illusionistic joke of the painting) to be actually sitting inside the packet. Further evidence of the way in which Hockney at this time was taking the language of painting as part of his subject-matter is provided by the fact that he exhibited the Ty-Phoo picture in 1962 under the title *Demonstration of Versatility – Tea Painting in an Illusionistic Style*. It is one of four *Demonstrations,* another of which, *A Grand Procession of Dignitaries in the Semi-Egyptian Style,* also marks his first (but by no means his last) use of earlier art as a source.

There is no doubt that David Hockney was the dominant personality in the Royal College group, and he has had a greater success than any of them. In fact his brilliant success and his personal style have made him, like Andy Warhol in America, a Pop star himself; and many of his more recent paintings depict the surroundings of successful Pop personalities – *California Seascape,* and the series of California

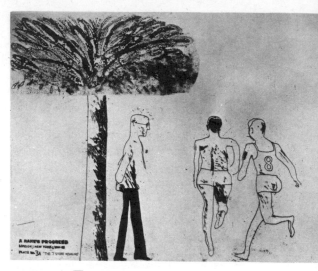

David Hockney. *The 7 Stone Weakling*, 1961–62. Etching from *The Rake's Progress*.

swimming pools, for example – as well as the personalities themselves.

Allen Jones, like David Hockney, gained a rapid success after the 1961 'Young Contemporaries' exhibition. His earliest themes were, in rather odd contrast, sex on the one hand and buses, aeroplanes and parachutists on the other. His style was both painterly and abstract, closer to Richard Smith in its approach than any of the other artists of the Royal College group (although, as we have seen, Kitaj was also important to him). As well as adopting a painterly approach, Jones also used the important formal device of the shaped canvas. In his famous series of bus paintings of 1962–63, many of the canvases are staggered rectangles that seem to lean forward along the wall, physically implying movement; and in a number of them, too, the wheels were painted on a separate piece of canvas and literally attached to the

bottom of the canvas. The effect of this is to give the image a greater reality and impact than it could have if simply depicted as a figure on a ground.

Erotic imagery first appeared in two *Bikini* paintings in 1962, although these were still, like the bus paintings, very abstract. The eroticism became explicit in paintings of couples and hermaphrodites like *Man-Woman* (1963), and in the single figure pin-up girls like *Curious Woman* (1964), which has the breasts actually modelled in three dimensions. In recent years Jones's obsession has become more intense, and he has expressed it in a much tighter, glossier style than before. His sources lie particularly in those sex magazines catering for underwear, rubber and leather fetishists, and in 1969 he produced a number of pieces of erotic furniture consisting of very realistically modelled and glamorous girls wearing leather boots and harness, offering themselves as seats, hatstands and *Girl Tables*.

Derek Boshier was the third member of the Royal College group to adopt a painterly semi-abstract approach to painting Pop imagery, but right from the beginning he tended to blend passages of extreme painterliness with bold, clear cut figurative images. In *Identi-Kit Man* (1962), one of his very best early works, the raw canvas is beautifully brushed with long feathery strokes of white, blue and mauve to create an effect of pale atmospheric colour which contrasts strongly with the flat, sharply outlined giant green toothbrushes and the vivid red and white stripes of the toothpaste. It is clear that the heraldic quality of the striped toothpaste made a strong appeal to Boshier, and in the next few years he evolved a kind of bright jazzy painting based on such sources but from which all figurative references were eliminated. Since 1964 he has been a completely abstract artist.

Anthony Donaldson was at the Slade School, and did not develop a fully fledged pop iconography and treatment until about a year later than the Royal

College group. But from 1962 he produced brightly coloured paintings, based mostly on repeated images of strippers, in which the tones are manipulated in such a way as to produce a constant strong image-ground reversal which makes the painting extremely abstract in its effect. By 1963 he was producing jazzy, optically active works in which the imagery was no longer readable, although there were still strong references to the source. More recently his work has become more figurative and more specifically erotic,

43 and *Girl Sculpture* (1970) effectively combines the sensuality of the nude girl with the extreme sensuousness of a beautiful gold flake acrylic paint job.

Superficially Patrick Caulfield is the British artist who appears to be closest to Roy Lichtenstein: he presents, like Lichtenstein, boldly outlined figurative images which in fact are part of a rigorously abstract formal structure. However, his imagery has none of the assertiveness usual in Pop art, and he does not draw on advertising or indeed any of the usual Pop sources. Instead he uses images which, while being

44 instantly familiar and recognizable, as in *Pottery,* for example, are so extremely unassertive as to emphasize to a degree greater than in any Pop artist the purely formal message of the work.

Having played a major part in laying the foundation of Pop art in Britain in the 1950s, Paolozzi insists that he is not a Pop artist and that, if anything, he is a Surrealist. However, it is almost impossible to look at Pop art in Britain in the 1950s and not take his work account, particularly his striking sculptures based on machinery and the heavy industrial aspects of the

46 city landscape like electricity sub-stations. *The Last of the Idols* (1963) combines solid architectural forms with a wheel, is topped off with what looks like a heavy electrical insulator and has a hard paint finish like that of heavy machinery.

Significantly these works (from 1962 onwards) were made for Paolozzi at an engineering works near

Ipswich, and they are assembled (welded) either from stock machine parts available from manufacturer's catalogues or from machine parts made to Paolozzi's own specifications. More than any other artist connected with Pop art, Paolozzi has pursued the logic of using industrial processes to make an art whose source itself lies in the industrial world.

Like Paolozzi, Joe Tilson is an artist whose sources lie in the urban, industrial and commercial scene, but whose aesthetic aims in almost all his work of the 1960s have been very different from those of the Pop artists. However, Tilson has made a number of purely Pop works, in particular the series of *Transparencies* started in 1967 and including images of Yuri Gagarin, Che Guevara and the Five Senses, one of which, 42 *Transparency Clip-O-Matic Lips*, with its huge glistening mouth and gleaming teeth, is a stunning presentation (relating more to the erotic than to the sense of taste which it is supposed to represent) of an image presumably culled from a toothpaste ad.

Continental Europe

It has frequently been pointed out that true Pop art, both for sociological and intellectual reasons, is an Anglo-Saxon phenomenon. But the revolt against Abstract Expressionism which gave rise to Pop art in America found its counterpart in Continental Europe at the same time, and produced a kind of art clearly related to Pop. This art is best understood in the context of *Nouveau Réalisme* or New Realism, a movement founded originally in 1960 by the French critic Pierre Restany and a small group of artists (among them, Yves Klein and Arman); the term quickly came to be applied to any artist following this tendency, whether he was a member of Restany's original group or not.

Restany published the first manifesto of New Realism in April 1960 in Milan (New Realism was to operate mainly on a French-Italian axis, with the Germans keeping somewhat to themselves). In it he

stated in florid rhetoric his rejection of the existing situation in art: 'We are witnessing today the exhaustion and sclerosis of every existing vocabulary, of all the languages, of all the styles', and then went on the propose a remedy. 'What are we going to put in their place? The fascinating adventure of the real seen as itself and not through the prism of an imaginative and intellectual transcription.' In spite of the firmness with which Restany asserts that there will be no imaginative or intellectual transformation of the source material, there is no doubt that the basic attitude of the New Realists towards urban reality was both intellectual and romantic, whereas that of the Anglo-Saxon Pop artists was intellectual and *cool*, i.e. classic. This is made clear by Restany himself in the second manifesto, published in Paris in 1961: 'The New Realists consider the world as a picture, the great fundamental masterpiece from which they take fragments endowed with universal significance.' This significance, for Restany, was a sociological one: 'And through these specific images the whole social reality, the common wealth of human activity, the great republic of our social intercourse, of our social activity, is brought before us.'

This second manifesto of New Realism bore the title 'Forty Degrees above Dada', a clear acknowledgment of Restany's debt to that movement, and especially to Duchamp. Like the American and British Pop artists, he took his point of departure from the readymade. 'In the present context,' he wrote, 'Duchamp's readymades take on a new significance. They translate the right to direct expression of a whole organic sector of modern life, that of the city, the street, the factory, of mass production. . . . The anti-art gesture of Duchamp will henceforth be *affirmative*. . . . The readymade is no longer the height of negativity but the basis of a new expressive vocabulary.'

There is no doubt that the most original and the most influential of the New Realists was Yves Klein,

who died prematurely in 1962. His aims were, ultimately, quite different from those of the rest of the group. Klein's works which have most relevance to

47 New Realism are his *Anthropometries*, paintings of the female nude made by applying the paint direct to the girl's body and imprinting her on the canvas. Klein's real concern was not with the external world but with the reality of art, and particularly with the reality of colour, which he felt embodied the essence of art. From 1949 onwards he produced a large number of monochrome paintings in pink, blue and gold, and finally, in 1957, settled on blue as representing the essence of colour. In the last few years of his life he

49 produced a series of 194 paintings in an unearthly, pure ultramarine blue which became known to the art world simply as I K B – International Klein Blue. Being the essence of art, this blue could be applied to any support, and *Lecturer I K B Elegant* is one of the many works Klein made basically from sponges soaked

48 in his blue. His portrait of Arman, a cast of the artist's torso coated with I K B and mounted on a gold-leaf ground, is considered by many to be his masterpiece.

Apart from Klein the New Realists tend to fall into a number of groups using different approaches and techniques. First, the painters: Alain Jacquet, Martial Raysse, Valerio Adami, Gerd Richter, Konrad Lueg and Winfred Gaul. Second, those who use the techniques of assemblage but in a basically two-dimensional form related to painting: Arman and Daniel Spoerri. Third, those who use techniques of assemblage in a fully three-dimensional sculptural form: César and Christo. Fourth, those who use collage: Michelangelo Pistoletto and Oyvind Fahlström. Fifth, those who use décollage, that is, the torn poster technique: Raymond Hains, Mimmo Rotella and Wolf Vostell.

Alain Jacquet uses the silkscreen process to put his images through a succession of transformations which

50 makes them more and more abstract. *Déjeuner sur*

l'herbe is one of his best-known works, one of the series he calls *camouflages,* which are all based on very well known works of art. In this case Jacquet has re-constructed, using live models beside a swimming-pool, and photographed, Manet's famous *Déjeuner* in the Louvre. (The Manet itself, of course, was based on a famous engraving after Raphael by Marcantonio Raimondi.) His photograph of this group has then been blown up to such enormous size that, when silk-screened on to the canvas, it functions as strongly as an abstract pattern of colour as it does as a figurative image with complex references both to art and to life.

Valerio Adami depicts the urban and suburban landscape, as in his *Showcase,* in a style in which objects are simplified, abstracted and distorted to the point where they are often difficult to read, and are painted in flat, brilliant Pop colours surrounded by strong black outlines.

Martial Raysse is one of the best-known New Realists, largely because his work is probably closer to Pop art than that of any of the other Europeans. Raysse has made extensive use of assemblage and mixed media, creating complete tableaux like his *Raysse Beach,* which uses an inflatable children's paddling-pool, garish plastic beach equipment and photographs of girls in bathing suits, but his most interesting works in the context of Pop art are his more or less straight paintings (some have neon attachments) in which images of girls have garish, extremely synthetic colour superimposed on them. He has also made a series of *tableaux affreux* (awful pictures), generically titled *Made in Japan* (still in the early 1960s a phrase implying cheapness, imitation, etc.), in which revered old master paintings like Ingres' *Odalisque* were, like the girls, rendered in lurid colour.

The German artists Gerd Richter and Conrad Lueg organized the 1963 'Demonstration of Capitalist Realism' in Düsseldorf, and both of them use photo-

54

graphic sources for their paintings, although in very different ways. Richter most characteristically uses landscapes, or people in movement, but blurs them to convey a cinematic sense of instability and scale. Lueg's paintings on the other hand present strong, sharply outlined images in which internal details are run together to create large abstract areas of colour somewhat like Lichtenstein.

Winfred Gaul began his career as a painter of imaginary landscapes but in 1961 a visit to Rome turned him on to the urban environment and in particular to traffic signs and signals. Since then he has virtually painted nothing else, and he has said of his paintings that 'their aesthetics are grounded in the garish colours and gigantic forms which are the new dimensions of city life, they constitute an art-form which has its habitat amongst the skyscrapers and the new industrial buildings, amongst the lines of traffic at the intersections on the motorways'.

Arman (Armand Fernandez) is one of the best known and most typical exponents of New Realism. Already in 1959 before the group was formed he was making what he called *Allures*, which involved making impressions on the canvas using objects dipped in paint; and in the same year he began the use of assemblage which has remained his basic technique. *Anger – Broken Table* (1961) is one of his early series of assemblages of smashed everyday objects all titled *Anger*. Also at this time he began to explore the aesthetics of accumulation, piling up valueless objects like bottle caps and presenting them in glass fronted cases, or more recently, embedded in slabs of clear plastic to become precious art works. One of his most striking accumulations, however, is a fully three-dimensional work, the famous *Torso* of 1967 in which dozens of rubber gloves are embedded in a clear plastic female torso, creating the disturbing impression that the woman is being groped from within by disembodied male hands.

Daniel Spoerri's use of assemblage involves the
53 element of chance to a very high degree. His *tableaux-pièges,* or 'snare paintings', are works in which accidental arrangements of everyday objects, e.g. a table top after a meal complete with dirty glass, crumbs, cigarette ash in the ashtray, would literally be trapped, fixed to a base, and then hung up on the wall.

César (César Baldacchini), the most eminent of the New Realist sculptors, has always been fascinated by machinery. From 1955 to 1960 he produced sculptures welded from scrap iron and machine parts, and in 1960
57 he began to make his *Compressions* – sculptures made from compressed car bodies or parts. The materials for these works are selected by César who also directs their arrangement in the car-crusher which plays the conclusive part in the creative process.

Christo (Christo Jaracheff) is a sculptor who works directly with existing objects, wrapping them up in many-layered parcels (the final layer sometimes being transparent polythene), so that the resulting sculp-
56 tures, like his marvellous early work the *Wrapped Bottle* of 1958, take on a mysterious poetic quality and invite the spectator to speculate endlessly as to what they may contain while the original mundane object remains quite untampered-with inside. More recently Christo has moved away from his involvement with objects and has grappled directly with the city itself and with the natural world. He packaged his first building in 1968 (the Kunsthalle, Berne), and in 1969 he wrapped a one-mile section of the Australian coastline near Sydney.

Michelangelo Pistoletto and Oyvind Fahlström both use collage in a highly individual way. Pistoletto uses life-size photographs of people, usually in informal everyday poses, and – in his most effective
59 works, like *Man Reading* – doing something that would not be out of place in an art gallery. These images are transferred on to tissue paper and applied to large polished steel mirrors. The mirror reflects

the environment in which the work is hung, so that Pistoletto's figures appear to be actually in the room or gallery together with the spectator, who, of course, in his turn becomes part of the work when reflected in it. Pistoletto has said that the first real figurative experience man has is when he recognizes his own image in a mirror.

61 Fahlström's use of collage is unique in that the collage elements of his paintings are movable, enabling the spectator to manipulate and rearrange their complex imagery relating, among other things, to politics, science, sport, day-to-day events, comic strips, and thus give the work a new appearance and a new meaning.

55, 60 The décollage, or torn poster technique, of Hains, Rotella and Vostell has been a particularly fruitful development within New Realism. Their torn advertisements are a strong and direct way of presenting commercial art imagery while at the same time vividly evoking the sleazier aspects of the urban environment.

Roy Lichtenstein. *Cup of Coffee,* 1962. Pencil, 22½ × 17½ (57.2 × 44.5). Collection Mr and Mrs Leo Castelli, New York.

Chronology

1947 London: Eduardo Paolozzi starts to make collages using images from magazines and advertisements.

1949 London: Francis Bacon begins to use photographic sources.

1952 London: Independents' Group (IG) formed at Institute of Contemporary Art, London.

1953 London: exhibition 'Parallel of Art and Life' organized by Paolozzi, Nigel Henderson (a photographer) and Alison and Peter Smithson.

1954–55 London: IG reconvened by Alloway and McHale specifically to discuss popular culture.

1955 New York: Robert Rauschenberg makes first combine painting, Jasper Johns produces first flag and target paintings.
London: Richard Hamilton's exhibition of paintings at the Hanover Gallery is much discussed at the IG in relation to use of popular imagery. Richard Hamilton organizes exhibition 'Man, Machine and Motion'.

1956 London: exhibition 'This is Tomorrow' at Whitechapel Gallery. Contributors include Hamilton, Paolozzi and the IG members. Emergence of key pop themes: Marilyn Monroe, cinema ads, packaging.

1957 London: Richard Smith shows painting *Blue Yonder* at 'Young Contemporaries', combining large-scale abstraction with popular figurative references.

1958 London: Hamilton starts work on *$he*.
Paris: Yves Klein makes first *Anthropometries*. Christo makes first wrapped objects.

1959 New York: Claes Oldenburg's exhibition 'The Street' at Judson Gallery.
London: David Hockney, Derek Boshier, Peter Phillips, R. B. Kitaj all at Royal College of Art.
Paris: Arman produces his first assemblages.

1960 New York: Andy Warhol makes first comic strip painting, *Dick Tracy*. Tom Wesselmann exhibits his first *Great American Nudes* at the Tanager Gallery. James Rosenquist develops his Pop style.
London: Allen Jones and Patrick Caulfield at Royal College of Art.
Paris: César makes first *Compressions*.

Milan: Critic Pierre Restany publishes first manifesto of New Realism.

1961 New York: Roy Lichtenstein independently paints his first works based on comic strips (Mickey Mouse, Donald Duck) and advertisements. Claes Oldenburg opens his 'Store' on East 2nd Street.

California: Pop art begins to develop on the West Coast. London: the Royal College group emerge at the 'Young Contemporaries' exhibition; Kitaj, Blake and Hockney are prizewinners at the John Moores Liverpool exhibition.

Paris: Second manifesto of New Realism published.

1962 USA: Andy Warhol paints Marilyn Monroe and Campbell's soup cans, and has his first show at the Jeans Gallery in Los Angeles. Ed Ruscha produces his first book of photographs, *Twenty-six Gasoline Stations*. In September–November Pop art in the USA is fully established with G. R. Swenson's interviews with Lichtenstein, Warhol, Wesselmann, Rosenquist and others, published in *Art News*, and with two exhibitions, 'The New Painting of Common Objects' at the Pasadena Art Museum and 'New Realists' at Sidney Janis in New York.

London: BBC-TV film 'Pop goes the Easel' with Boshier, Phillips, Blake and Pauline Boty. Pop art is now a firmly established and fully identified movement.

Europe: New Realism develops on a French–Italian axis.

1963 Düsseldorf: German artists Gerd Richter and Conrad Lueg organize a 'Demonstration of Capitalist Realism'.

Further Reading

The literature of Pop art is mostly scattered in periodicals and exhibition catalogues, and thus not widely available. However, there do exist a number of general works on the subject which serve as a guide to further study. First in the field were John Rublowsky, *Pop Art*, and Mario Amaya, *Pop as Art*, both London and New York, 1965. Lawrence Alloway has written important contributions to Lucy R. Lippard, ed., *Pop Art*, London and New York, 1966, and to *Figurative Art Since 1945*, London and New York, 1971; the latter is also an important source on New Realism. An Anglo-American round-up (with a unique collection of

seminal Pop texts, including some of G. R. Swenson's historic interviews, and the classic statements by Oldenburg, Rauschenberg and others), was John Russell and Suzi Gablik, *Pop Art Redefined,* London and New York, 1969. Michael Compton's valuable *Pop Art* was published in London and New York in 1970.

List of Illustrations

Measurements are given in inches and centimetres, height first.

11 Andy Warhol (1930–). *Green Disaster,* 1963. 81¼ × 90½ (206.5 × 230). Collection Karl Ströher, Hessisches Landesmuseum, Darmstadt. See p. 17.

12 Andy Warhol (1930–). *Green Coca-Cola Bottles,* 1962. Oil on canvas, 82¼ × 57 (208 × 145). Whitney Museum of American Art, New York. See p. 14.

13 Andy Warhol (1930–). *Pink Cow (Cow Wallpaper),* 1966. Serigraph, 44 × 30 (112 × 76). Courtesy Leo Castelli Gallery, New York. See p. 16.

14 Andy Warhol (1930–). *Self-portrait,* 1967. Acrylic colour print on canvas, 72⅛ × 72⅛ (183.5 × 183.5). Tate Gallery, London. See p. 18.

15 Claes Oldenburg (1929–). *Kitchen Stove,* 1962. Metal, porcelain, gesso and colour. Collection Mr and Mrs Robert C. Scull, New York. See p. 21.

16 Claes Oldenburg (1929–). *Giant Blue Pants,* 1962. Canvas, acrylic paint, length 54 (68.5). Collection William Harris, Chicago, Ill. See p. 21.

17 Claes Oldenburg (1929–). *Giant Fireplug,* 1969. Crayon and watercolour, 17½ × 12 (44.5 × 30.5). Private Collection, London. See p. 22.

18 Claes Oldenburg (1929–). *Trowel Scale B,* 1971. 40½ ft (12.2 m). Collection the artist, New York. See p. 22.

19 Claes Oldenburg (1929–). *Hamburger, Popsicle, Price,* 1962. Enamel paint on canvas stuffed with kapok, height 36 (117). Collection Mr and Mrs Charles H. Carpenter, Jr, New Canaan, Conn. See p. 22.

20 Claes Oldenburg (1929–). *Giant Soft Swedish Light Switch,* 1966. 51¼ (130). Collection Ludwig, Wallraf-Richartz Museum, Cologne. See p. 22.

21 James Rosenquist (1932–). *I Love You with my Ford,* 1961. Oil and canvas, 82½ × 93½ (210 × 237.5). Moderna Museet, Stockholm. See p. 24.

22 Tom Wesselmann (1931–). *Great American Nude no. 99,* 1968. Oil on canvas, 60 × 80 (152 × 203). Collection Morton G. Newman, Chicago, Ill. See p. 25.

23 Robert Indiana (1928–). *The Demuth Five,* 1963. Oil on canvas, 64 × 64 (162.5 × 162.5). Collection Mr and Mrs Robert C. Scull, New York. See p. 25.

24 Robert Indiana (1928–). *Love,* 1967. $33\frac{3}{4}$ × $33\frac{3}{4}$ (85.5 × 85.5). Collection Mr and Mrs Bagley Wright, Seattle, Wash. See p. 26.

25 Allan D'Arcangelo (1930–). *Highway No. 2,* 1963. Acrylic on canvas, 72 × 81 (183 × 206). Wasserman Family Collection, Chestnut Hill, Mass. See p. 26.

26 Billy Al Bengston. *Skinny's 21,* 1961. Oil on canvas, 42 × 40 (106.6 × 101.6). Private Collection, Beverly Hills, Calif. See p. 27.

27 Edward Ruscha (1937–). *Noise, Pencil, Broken Pencil, Cheap Western,* 1963. Oil on canvas, 77 × $66\frac{1}{2}$ (195.5 × 169). Collection Mr and Mrs Thomas G. Terbell, Jr, Pasadena, Calif. See p. 28.

28 Edward Ruscha (1937–). *Standard Station, Amarillo, Texas,* 1963. Oil on canvas, 65 × $121\frac{1}{2}$ (49.7 × 94). Collection Heinz Beck, Düsseldorf. See p. 28.

29 Mel Ramos (1935–). *Ode to Ang,* 1972. Oil on canvas, 70 × 37 (178 × 94). Wilp Collection, Düsseldorf. See p. 30.

30 Wayne Thiebaud (1920–). *Refrigerator Pies,* 1962. 20 × $16\frac{1}{8}$ (51 × 41). Pasadena Art Museum, Pasadena, Calif. Gift of Paul Beckman. See p. 30.

31 Richard Hamilton (1922–). *Just What Is It That Makes Today's Homes So Different, So Appealing?,* 1956. Collage, $10\frac{1}{4}$ × $9\frac{3}{4}$ (26 × 25). Collection Edwin Janss, Jr, Thousand Oaks, Calif. See p. 37.

32 Richard Hamilton (1922–). *$he,* 1958–61. Oil, cellulose, collage on panel, 24 × 16 (122 × 81). Tate Gallery, London. See p. 38.

33 Peter Blake (1932–). *On The Balcony,* 1955–57. Oil on canvas, $47\frac{3}{4}$ × $35\frac{3}{4}$ (116 × 91). Tate Gallery, London. See p. 42.

34 Peter Blake (1932–). *The Love Wall* (detail), 1961. 49 × 93 × $9\frac{1}{8}$ (124.5 × 236.2 × 23). The Calouste Gulbenkian Foundation, Lisbon. See p. 44.

35 Peter Blake (1932–). *Toy Shop,* 1962. Mixed materials, $61\frac{3}{4}$ × $76\frac{3}{8}$ × $13\frac{3}{8}$ (157 × 194 × 34). Tate Gallery, London. See p. 42.

36 Allen Jones (1937–). *Girl Table,* 1969. Painted glass fibre and resin, tailor-made accessories, life-size. See p. 49.

37 Allen Jones (1937–). *Man–Woman,* 1963. Oil on canvas, 84 × 72 (213 × 183). Tate Gallery, London. See p. 49.

38 R. B. Kitaj (1932–). *Synchromy with F.B.,* 1968–69. Wing of a diptych, oil on canvas, 60 × 36 (152.5 × 91.5). Marlborough Fine Art Ltd, London. See p. 45.

39 David Hockney (1937–). *Tea Painting in an Illusionistic Style,* 1962. Oil on shaped canvas, 78 × 30 (198 × 76). Situation Gallery, London. See p. 47.

40 David Hockney (1937–). *California Seascape,* 1968. Acrylic on canvas, 82 × 120 (214 × 305). The Hon. James Dugdale, Yorkshire. See p. 47.

41 Derek Boshier (1937–). *Identi-Kit Man,* 1962. Oil on canvas, 72 × 72 (183 × 183). Tate Gallery, London. See p. 49.

42 Joe Tilson (1923–). *Transparency Clip-O-Matic Lips,* 1968. 32½ × 27 (82.7 × 68.6). Marlborough Graphics, London. See p. 51.

43 Antony Donaldson (1939–). *Girl Sculpture (Gold and Orange),* 1970. 29½ × 177½ (75 × 448). Collection the artist. See p. 50.

44 Patrick Caulfield (1936–). *Pottery,* 1969. Oil on canvas, 84 × 60 (213 × 152.5). Tate Gallery, London. See p. 50.

45 Richard Smith (1931–). *Quartet,* 1964. Oil on canvas, 56 × 72 × 20½ (117 × 183 × 52). Collection Walker Art Center, Minneapolis, Minn. See p. 46.

46 Eduardo Paolozzi (1924–). *The Last of the Idols,* 1963. 96 × 24 × 4⅜ (244 × 61 × 11). Collection Ludwig, Wallraf-Richartz Museum, Cologne. See p. 50.

47 Yves Klein (1928–62). *Suaire ANT SU 2 (Anthropometry),* 1962. 50½ × 26 (128 × 66). Moderna Museet, Stockholm. See p. 53.

48 Yves Klein (1928–62). *Relief (Arman),* 1962. 69¼ × 37 (176 × 94). Musée National d'Art Moderne, Paris, lent by Centre National d'Art Contemporain. See p. 53.

49 Yves Klein (1928–62). *Monochrome Blue,* 1959. Galleria Apollinaire, Milan. See p. 53.

50 Alain Jacquet (1939–). *Déjeuner sur l'herbe,* 1964. 69 × 78¼ (175 × 197). Galleria Nazionale d'Arte Moderna, Rome. See p. 53.

51 Valerio Adami (1935–). *Showcase.* Acrylic emulsion and polymer on canvas, 51 × 64 (130 × 162). Collection Withofs, Brussels. See p. 54.

52 Martial Raysse (1936–). *Made in Japan en Martialcolor,* 1964. 45½ × 35 (116 × 89). Archives Galerie Alexandre Iolas, New York, Paris, Geneva, Milan, Rome. See p. 54.

53 Daniel Spoerri (1930–). *Robert's Table,* 1961. Snare painting (assemblage), 78¾ × 19¾ (200 × 50). Collection Ludwig, Wallraf-Richardtz Museum, Cologne. See p. 56.

54 Arman (Armand Fernandez, 1928–). *Anger – Broken Table,* 1961. Assemblage, 55 × 47½ (140 × 121). Centre National d'Art Contemporain, Paris. See p. 55.

55 Wolf Vostell (1932–). *Coca-Cola,* 1961. Decollage (torn posters), 82¾ × 122⅛ (210 × 310). Wallraf-Richartz Museum, Cologne. See p. 57.

56 Christo (Christo Jaracheff, 1935–). *Wrapped Bottle,* 1958. Assemblage, 17¾ × 3 (45 × 7.5). Collection Kimiko and John Powers. See p. 56.

57 César (César Baldaccini, 1921–). *Compression,* 1960. 60 × 31 × 25½ (153 × 73 × 65). Musée National d'Art Moderne, Paris. See p. 56.

58 Gerhard Richter (1932–). *Landscape,* 1970. Oil on canvas, 31½ × 39⅜ (80 × 100). See p. 55.

59 Michelangelo Pistoletto (1933–). *Man Reading,* 1968. 90 × 47 (228 × 120). Kornblee Gallery, New York. See p. 56.

60 Mimmo Rotella (1918–). *In Red with Woman,* 1961. Décollage (torn posters), 27 × 41¾ (70 × 106). Galleria Tartaruga, Rome. See p. 57.

61 Oyvind Fahlström (1928–). *The Little General,* 1967. Various structures in a water-filled plexiglass tank; oil on photo and vinyl fixed on formica, expanded polystyrene. 20 × 217 × 110 (50.8 × 553.8 × 279). Sidney Janis Gallery, New York. See p. 57.

62 Winfred Gaul (1928–). *Homage to Berlin,* 1964. Painting on metal panels. See p. 55.

COVER Mel Ramos (1935–). *Philip Morris,* 1965. Silkscreen. 28 × 22 (71 × 56). Collection Kimiko and John Powers. See p. 30.

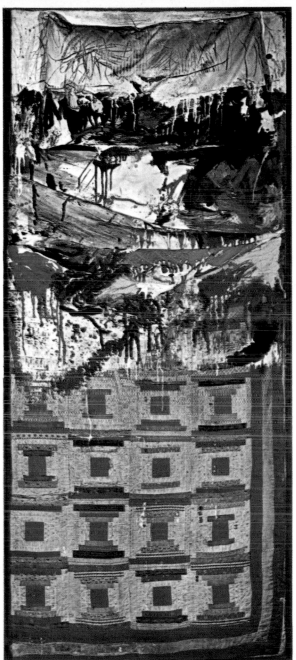

1

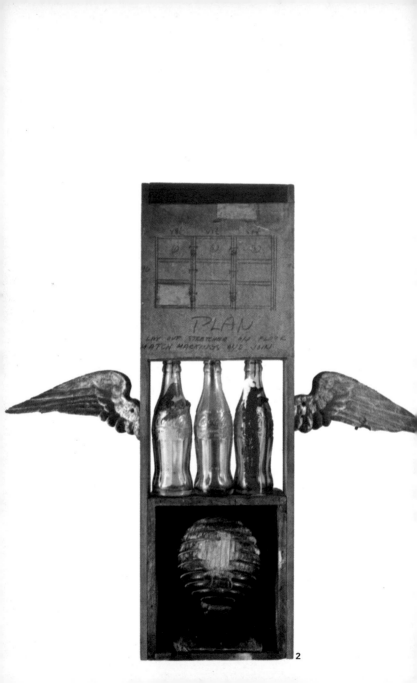

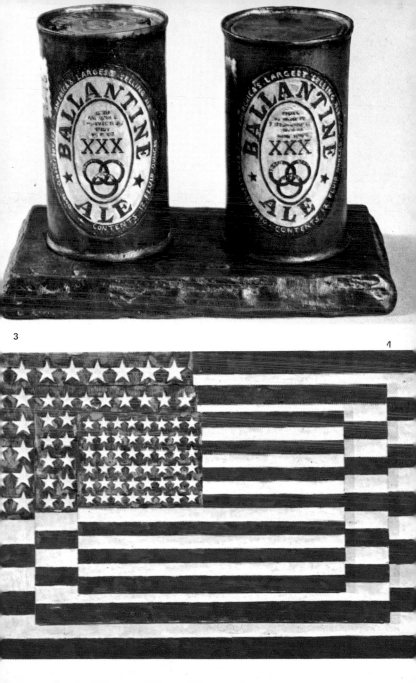

3

1

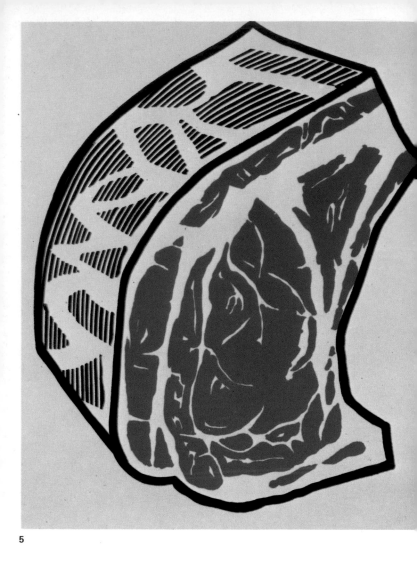

5

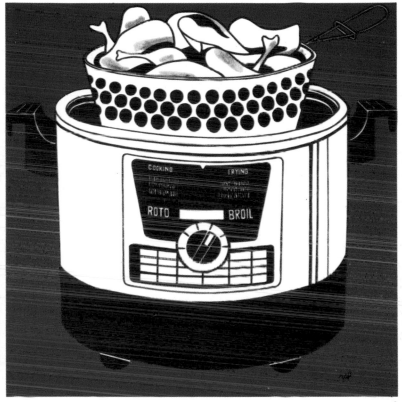

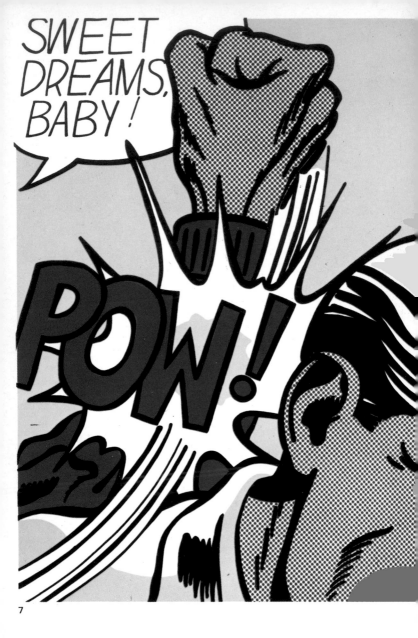

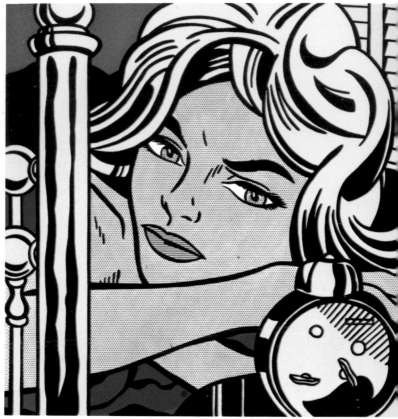

9

11

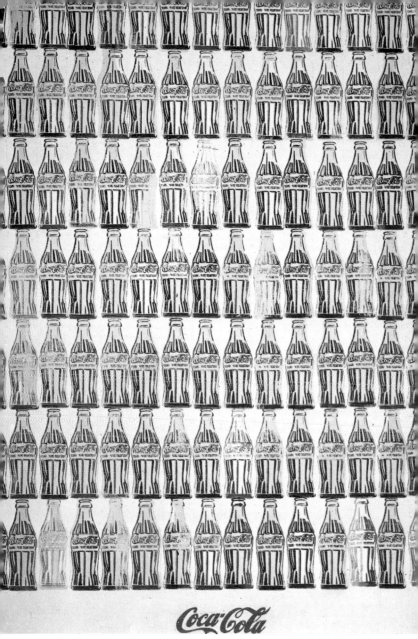

13

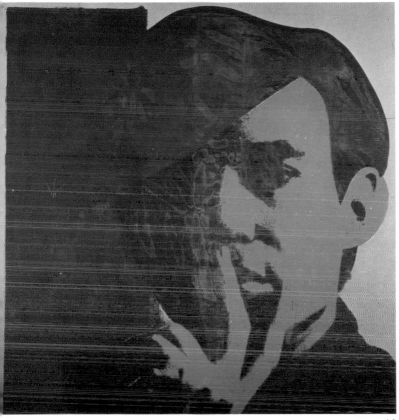

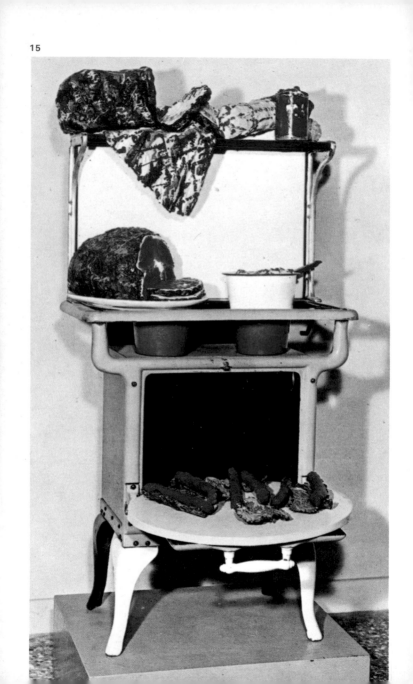

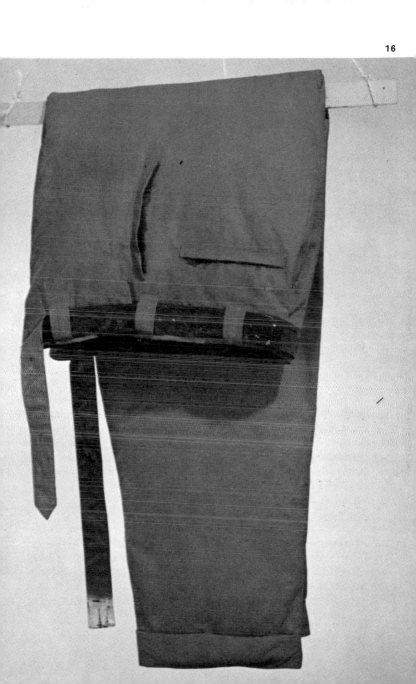

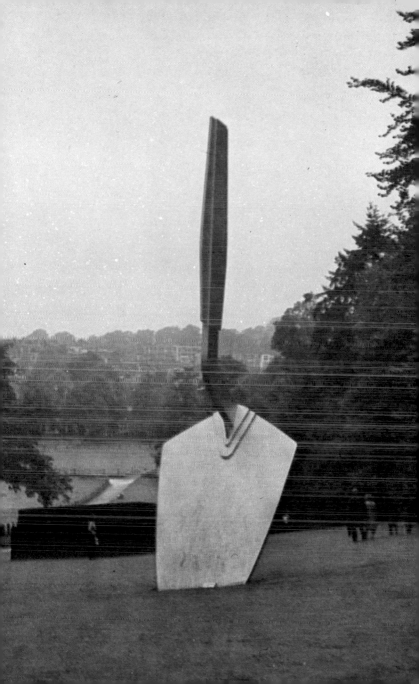

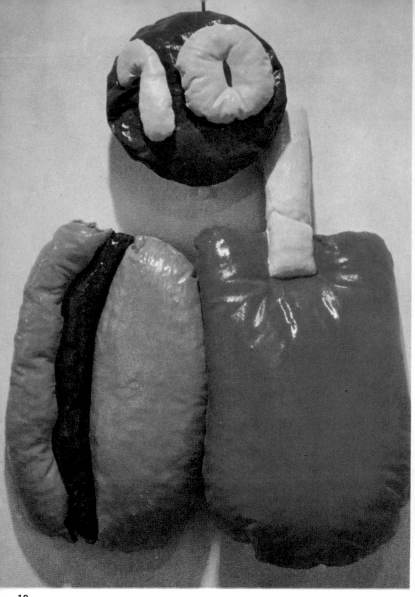

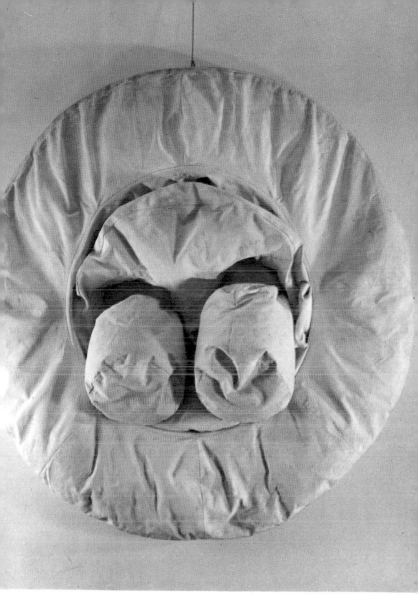

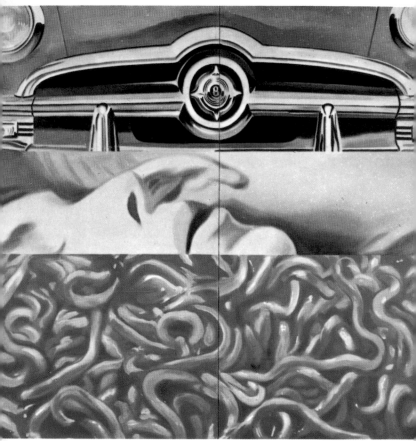

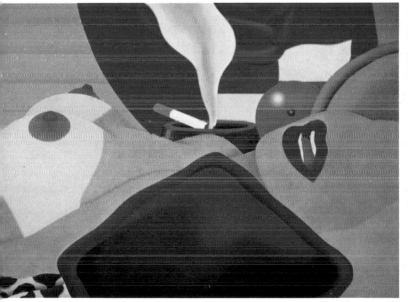

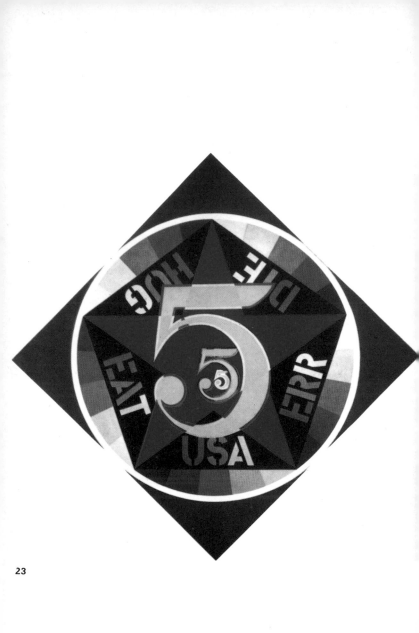

23

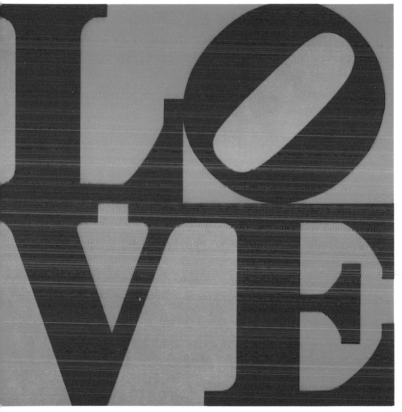

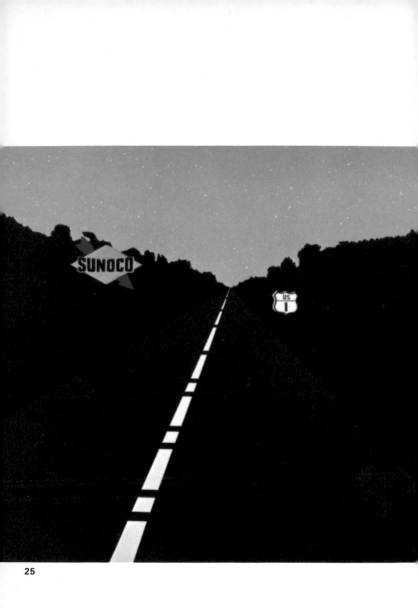

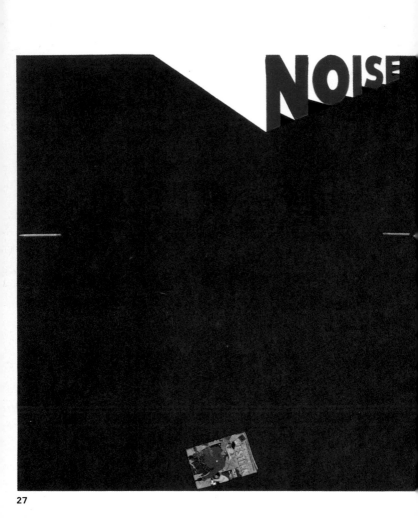

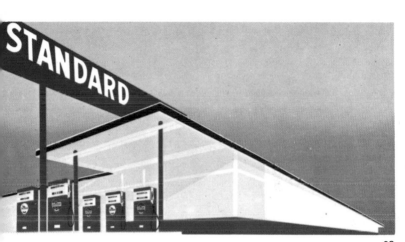

28

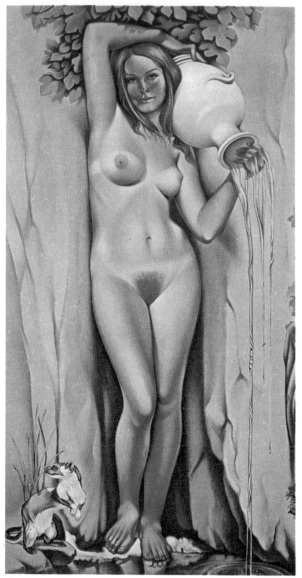

29

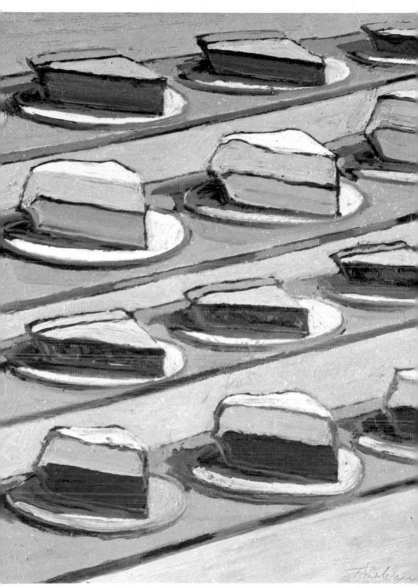

30

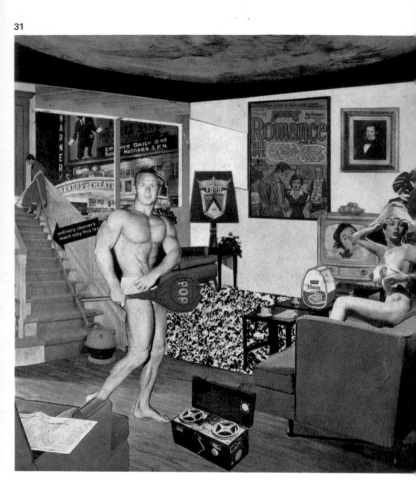

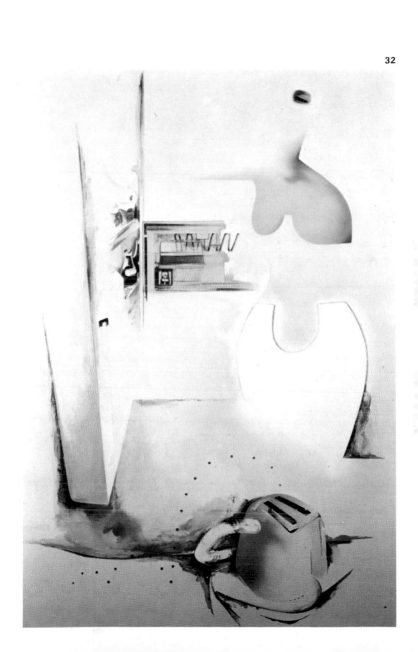

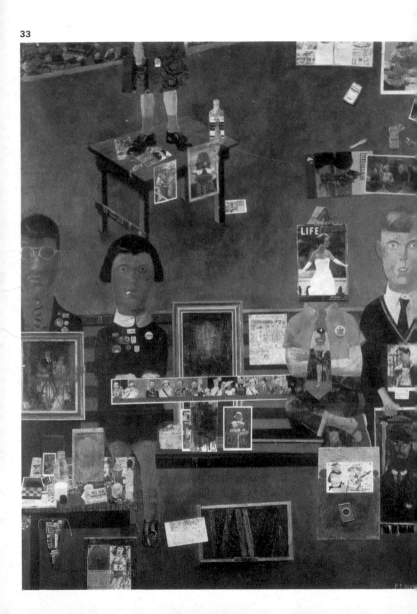

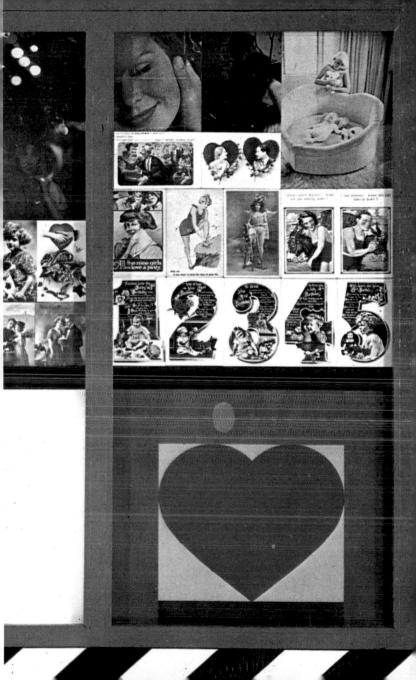

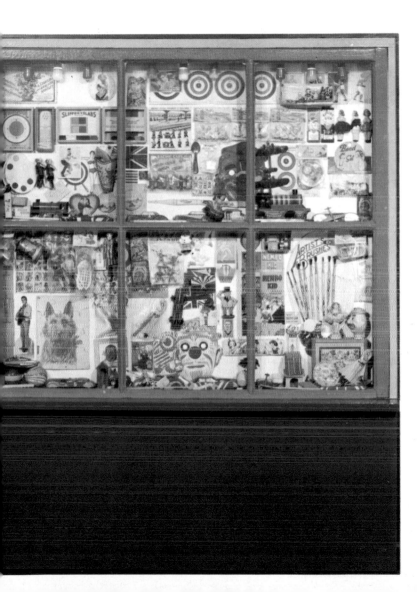

36

38 *Symphony with F.B.*

41

43

45

Arman
1961

54

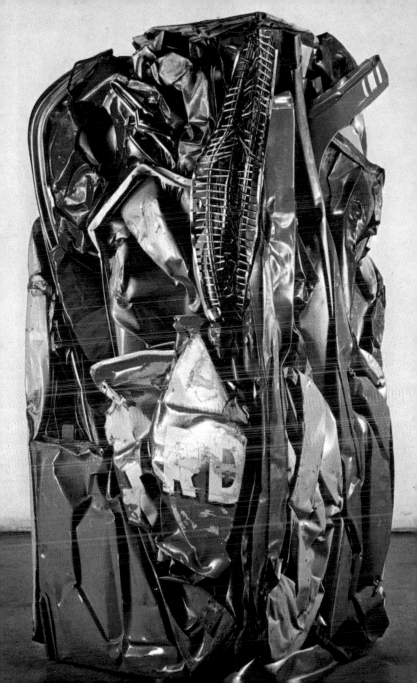

58

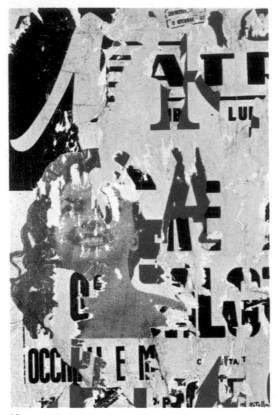

60

61